CW00833047

IMAGE & VISION

IMAGE & VISION

REFLECTING WITH THE BOOK OF KELLS

ROSEMARY POWER

VERITAS

Published 2022 by
Veritas Publications
7–8 Lower Abbey Street
Dublin 1, Ireland

publications@veritas.ie
www.veritas.ie

ISBN 978 1 80097 008 3

Copyright © Rosemary Power, 2022

Images from the Book of Kells reproduced courtesy of the
Board of Trinity College Dublin

10 9 8 7 6 5 4 3 2 1

The material in this publication is protected by copyright law. Except
as may be permitted by law, no part of the material may be reproduced
(including by storage in a retrieval system) or transmitted in any form or by
any means, adapted, rented or lent without the written permission of the
copyright owners. Applications for permissions should be addressed to the
publisher.

A catalogue record for this book is available from the British Library.

Designed by Clare Meredith
Printed in Ireland by Walsh Colour Print, Kerry

*Veritas books are printed on paper made from the wood pulp of managed forests.
For every tree felled, at least one tree is planted, thereby renewing natural resources.*

Contents

Acknowledgements

Thanks are due to Trinity College Dublin for permission to use twelve illustrations from the Book of Kells. I am grateful to those scholars who have assisted me in interpretation of a work not in my own field; in theology, art history and early medieval studies. Their work has been of invaluable help and direction, and while they can only receive general acknowledgement in a book of this kind, I am deeply aware of the depth of their insights.

Donncha MacGabhann gave vigorous and deeply knowledgeable input on the images and text, through many conversations. Erich Poppe gave references and made perceptive comments on the background. Cathy Swift allowed the use of her unpublished translations of two early Irish poems. John Carey and Gilbert Márkus gave permission for the use of their translations. David Coleman provided the photographs of Iona's St Oran's and St Martin's crosses and, along with Brendan Meegan, gave perceptive insights on the artistic detail. The staff of Offaly County Library in Birr allowed me to work with their facsimile of the Macregol Gospels. The staff of the National University of Ireland, Galway and Nottingham University Hallward Library provided generous access to their collections.

Michael Brennan of the original Columba Press and Des Bain gave much-valued encouragement. Conversations and hospitality were provided by Jenny and Brendan Meegan, Kay Muhr and Brian Lambkin. The Benedictine community of Kylemore Abbey gave me the encouragement of space and silence while writing, as did Eilís and Donald Storrie. The late David Bunney undertook the initial proofreading.

Above all this book has benefited from the enthusiasm and comments of people of all ages who attended sessions on Iona, at Kells and in many libraries and schools in Ireland and Britain over the last twenty-five years, and who showed me more of the detail than I could have imagined. All errors of fact and interpretation remain my own.

Scriptural references in English are quoted from the *New International Version*, UK International Bible Society, Hodder and Stoughton, 1984.

List of Illustrations

Part 1

INTRODUCTION

There is a page in the Book of Kells, a copy of the four gospels written by hand in Latin about twelve centuries ago, that marks the story of Christ's birth according to Matthew. This passage was used on Christmas night, when the birth of Christ in Bethlehem of Judea was commemorated. To cite John's gospel, in the beginning was the Word, laboriously written by hand, illuminated at cost to the health of the artist as well as the budget of the monastery, and then opened so all could see something of the story, in visual design as well as words.

The Book of Kells, now battered, cropped, lacking pages and never completed, is one of the great treasures of western Christian art. It is a richly decorated copy of the four gospels, with some additional preliminary material. It is thought to have been made around 800 CE, perhaps to celebrate St Columcille, also known by his Latin name Columba (c.521–97), who died some two centuries earlier. It is likely that it was started on the Hebridean island of Iona, the place where Columcille died and the head of the federation of monasteries, the *familia*, which took its inspiration from him. Treated as a great relic, it was probably taken to the fellow Columban monastery of Kells in Ireland for safekeeping and perhaps completion during a time of Viking raids. It remained there until the seventeenth century, when it was taken to Dublin.

It is a single, unified work that contains great illuminated pages, each of them a work of art. It is a collection of powerful theological reflections on the nature of Christ and the ways in which the scriptures tell of Christ. In its pages there is an intense relationship between the visual art and the text. Each interprets the other, with the intention of allowing the onlooker to make new connections between passages of the scriptures, and to reflect on the gospels in new ways.

It holds the mystery of a great work of art, slowly enriching our understanding as we live with it. It is an imaginative product of the age that created it, and it has come down to us because in different ages since, people recognised its value and acted to preserve what they could of it.

It is a relatively small book, though it was once slightly larger, and some of the pages now sit crooked or have part of their content missing

where bad binding and cropping has damaged the work. It contains preliminary material related to the four gospels and then the texts of the gospels, though the end of the Book of Kells, including the last quarter of St John's gospel, is now missing. The text is written evenly across the page rather than in columns, in clear hands, and with only seventeen, or towards the end eighteen, lines to the page. This is less than was common, and gives a sense of lightness to the work, which is enhanced by the delicacy and vividness of the numerous small works of art it contains, including decorated capital letters and designs between the lines of text.

The full-page illuminations, pictures intended to deepen the reader's understanding and appreciation of the gospels, include abstract designs, portraits and full-page initials to mark the start of the gospels or the texts for major liturgies. Some of these are now missing and it is impossible to tell how many there were originally. Those that remain are not illustrations but are in the full sense illuminations, light-bringers that enlighten us, that illuminate the texts and their many levels of meaning.

The quality of its unified art and theology makes it distinct from the other gospel books of the time. Many of them are superb works of art, and religious foundations must have taken great pride in the skills that produced such treasures. But in the Book of Kells, behind all the energetic patterning we can see the thought of a great artist, of someone who had absorbed the scriptures into his being and produced something greater than the decorations that delight us.

This artistry is as far as we know unique, though there may have been one other gospel book as great. Nearly four centuries after the Book of Kells was compiled, an ambitious Welsh clergyman came to Ireland with the Normans, and in about 1185 saw a great gospel book at the women's foundation of Kildare, the sixth-century monastery associated with St Brigid. Often less than complimentary about matters Irish, he was overwhelmed.

> Among all the miracles of Kildare nothing seems to me more miraculous than that wonderful book which they say was written at the dictation of an angel during the lifetime of the virgin [Brigid]. This book contains the concordance of the four gospels according to St Jerome, with almost as many drawings as pages, and all of them in marvellous colours. Here

you can look upon the face of the divine majesty, drawn in a miraculous way; here too upon the mystical representations of the Evangelists, now having six, now four, and now two, wings. Here you will see the eagle, there the calf. Here the face of a man; there that of a lion. And there are almost innumerable drawings. If you look at them carelessly and casually and not too closely, you may judge them to be mere daubs rather than careful compositions. You will see nothing subtle where everything is subtle. But if you take the trouble to look very closely, and penetrate with your eyes to the secrets of the artistry, you will notice such intricacies, so delicate and subtle, so close together and well-knitted, so involved and bound together, and so fresh still in their colourings that you will not hesitate to declare that these things must have been the result of the work, not of men but of angels.[1]

Some manuscripts continue:

For myself the more often and more carefully I inspect these things, the more I am amazed anew, and I always see things which I admire more and more.[2]

Giraldus Cambrensis, Gerald of Wales, goes on to describe the work of an angel and St Brigid in helping the scribe with the design.

The Book of Kells may have been on loan to Kildare, and Giraldus Cambrensis may have slightly misremembered the contents, for it now contains no angels with six wings. It may have been an equally superb but now lost gospel book, perhaps written and illuminated, or at least commissioned, by the nuns of Kildare in honour of St Brigid.

Other great gospel books produced at the time, or earlier, have survived, giving us the opportunity to compare them and to understand the motivation that produced them, the artistic and liturgical purpose, and the techniques and materials. Some survive only in truncated form. We have only two pages from the gospel book known as Durham A.II.10, which was produced either in Ireland or England and used in the early years of Christianity in the northern English kingdom of Northumbria. They survived because centuries later they were used as dust covers for a

standard medieval tract. Other books have been more fortunate, like the Northumbrian Lindisfarne Gospels, a book that was probably made a hundred years before the Book of Kells. The writing and illumination are apparently the work of a single hand, and the same is true of the MacRegol Gospels (also known as the Rushworth Gospels), composed at about the same time as the Book of Kells, probably in the Irish midlands at Birr in what is now County Offaly. In both these cases there is a colophon, a final note, naming the scribe who was also the illuminator. (Curiously, while neither has been damaged like the Book of Kells, both of these Latin texts were later given an interlinear gloss in Old English.)

The great gospel books contain decorated capital letters and larger decorations, illuminations that mark major passages. The capitals helped the reader to find the text designated for use in the liturgy at a time when the scriptures were not divided into chapter and verse, and were read aloud indoors by limited light. Even when the text was known by heart, they were aids to the memory. Their elaboration probably meant that the open pages of the book were also displayed on important occasions, for the delight and inspiration of the people present.

We can assume that the Book of Kells was produced for its monastic community, for those associated with it, and for the pilgrims that came to stay and sometimes to die there. It was certainly the product of a large and wealthy foundation, and it was created with the support of many people. They would have expected their work to last indefinitely, but the story of the book's survival is very unlike what must have been envisaged.

Producing the Book

A book on this scale took considerable planning. The first requirement was calfskin. The skins of sheep or goats could be used for smaller books, such as psalters, which were carried about and passed around, but larger works required the finest vellum made from the skin of newborn calves. The maximum amount of vellum available from one animal was two sheets, four sides. Therefore, at least 180 calves were needed to produce the Book of Kells.

We do not know if there was a trade in prepared calfskins, or whether some came as rent for lands owned by the monastery, though the quality may suggest that they were all prepared at the same place. The work of

gathering the cows, helping them to give birth, slaughtering the calves, and then preparing the vellum, were major tasks in the spring and summer months.

A cow would bear in spring, and, when the calf was taken from her, she provided milk for human consumption. Meanwhile, the calf was slaughtered and carefully flayed. The skins were placed in a mixture of lime to loosen the hair and fat; then were scraped, cleaned, stretched and dried. They were smoothed again to remove impurities where possible, and finally cut to shape. The vellum would then be ruled as a guide for the scribe. Sometimes the skins tore, resulting in the script going around holes, though sometimes a hole was patched before writing. The vellum offcuts may have been used, together with wax tablets, to sketch designs.

The size of the pages was determined by the size of newborn calves. For some decorated pages, slightly older calves were selected, because their thicker skins were able to take the ink without the colour running through to obscure the text on the other side. While this also meant slightly coarser vellum in the Book of Kells, a number of major illuminations have used just one side of the skin.

Once prepared, vellum is hard to destroy, though fire and the nibbling of rodents or certain insects can damage it. Important books were preserved in shrines of precious metalwork, which had a practical use as well as being works of art in their own right, while humbler book-satchels of leather allowed less favoured books to be hung up, giving them some protection. Protection from mice was also provided by cats, which are frequently represented in the Book of Kells.

Vellum can also be affected by damp. Miracles, such as the lack of damage to the Lindisfarne Gospels after they are said to have fallen into the sea and later washed ashore, can be attributed to the edges swelling and preserving the text. The remains of a psalter found in an Irish bog in 2006 shows that to some extent vellum can even survive twelve centuries in adverse circumstances.

The final section of this book will consider the inks and the wide palette of colours, both local and imported, which were used in the Book of Kells; the monastic routine the original scribes and artists followed; and the contacts with other places that allowed a work like this to be produced.

There has been much debate about how many scribes and artists were involved in the creation of the Book of Kells. Bernard Meehan has summarised the debate to date in a section of his 2012 volume that covers the aspects of making the manuscript. Donncha MacGabhann has proposed that it is entirely the work of two people, identified by him as the Master-Artist and the Scribe-Artist. The Master-Artist was the leading artist, while his partner collaborated on some of the illumination and was responsible for the overall plan and all of the written script. Following some hiatus and a significant period of time, he believes that only the Scribe-Artist survived to continue the work. Debilitated by the effects of ageing (and possibly illness or injury), he attempted the completion of the manuscript.

The level of thought behind even minor details in the great illuminations indicates that the overall planner had a deep knowledge of the scriptures; and he connected passages from the Old Testament and from the epistles to the gospels to show continuity and the fulfilment of prophecy. There is an expectation that the reader shares this knowledge to some degree, and can make new links through the art and through accompanying prayer and reflection. One connection made again and again is that the four gospels are a single unit, to be reflected on together. Details taken from one gospel are referred to in the decoration of another, and each gospel is prefaced by a full-page image of the four evangelists' symbols united around a cross. While this is standard practice for many contemporary Christians, the emphasis through the visual makes the experience exceptionally rich.

Much work went into the illuminations found at the front of the Book of Kells, material that was at the time standard for preliminaries to the gospels. Furthermore, two portrait pages were produced on individual pieces of vellum and placed before or near the beginning of Matthew's gospel. Because of the use of single pages for some of the full-page illuminations, it is not certain how many are missing, or whether some were never made. However, it is clear that the great initial pages of each gospel and their own preliminary illustrations were planned from the start as a unified whole. The Book of Kells seems to have been conceived as richly decorated throughout, with special pages indicating high points of the liturgical calendar.

It is also a book to be seen rather than read. The text, based on the Vulgate Latin, contains some errors. There are corrections, as will be found in any medieval manuscript, but at times the scribes went by what they knew by heart and used earlier Old Latin versions of the scriptures rather than the copy before them. There are some odd mistakes too. A whole passage from Luke chapter seven, the account of the woman who was a sinner in the house of Simon the Pharisee, has been repeated by the same scribe on a second piece of vellum which was bound as the following page, and the first passage was marked as a mistake (fol. 218v–219r).[3] Another matter for a modern reader is that, although the basic text is written clearly, some of the illuminated pages are in scripts so ornamental they are hard to read, and were presumably known by heart within a monastic community. It seems that, unlike the MacRegol and many other gospel books, the Book of Kells was not intended for study. Indeed, reading aloud from a book this elaborate may have happened only occasionally.

There is also an effect that can be observed in the original and in fine art copies, but not those produced by electronic means. The great illumination pages give the impression of layers, of different parts of the decoration being on different planes, as with a work of metal. Sometimes this is because of the actual raising off the page that results from the use of two or three layers of colour, while the numerous borders can give the impression of raising certain sections, in a *trompe l'oeil* effect that gives a tremendous sense of depth; and where figures are involved, of movement.

The work was treated as a relic, a source of pride and comfort for the community. We do not know how many people saw it in its original monastic setting, and whether it was a treasure only rarely shown to the normal population and the pilgrims associated with the monastery. But the care that has gone into it means that the art, visible in some form to many of us today, in all its minute detail, demands our close attention.

The intention may have been to display the book at major church festivals, showing the onlookers the illumination relevant to the day, and then declaiming the associated passage of scripture. In an age when few could read, people's visual sophistication counted, and it may be that by displaying two open pages but no more on any one occasion, the illuminations could be presented throughout the year, as a sequence of icons.

The Book of Kells as an Image

The Greek word 'icon', with its full meaning of 'true image', reflects best what the book's artists intended. The illuminations are multivalent, that is, they relate to more than one piece of scripture at once, making connections, often between Old Testament and New, that were themselves drawn out of the prayer tradition of the community from which they come. Moreover, the images relate to each other as well as to the texts they illuminate. Scholarly work has connected the illuminations with what is known of the liturgies and rites used in the eastern Mediterranean and North African churches, in areas often at the fringes of Christendom that provided remnants of ideas and visual images that may once have been widespread. There appear to be references, noted by scholars like Jennifer O'Reilly, Carol Farr, Heather Pulliam, Felicity O'Mahony, Bernard Meehan, and many others, to the interpretations and sermons of early Church Fathers.

These links happened on several levels. The materials used to make the coloured inks give some indication of the trade and connections of the times in which this book was produced, and of the ways in which artistic interest and perhaps liturgical action flowed between places we now regard as remote and culturally distinct. What we see may hint at practices and understandings that were once widespread, through their local interpretation, with the Gaelic world, like the North African, providing its own unique flavour. The peoples who produced these great works of art used the sea for the movement of people and materials, observed a more flexible approach to time and spoke Latin to cross the boundaries of language.

Both in terms of artistry and content, this manuscript goes further than other works of its kind. Each of the great illuminations contains several layers of meaning. They are deliberately created to give new insights into the life of Jesus as told in the scriptures. They also give recognition to the ways in which the life of Jesus connects to the life of the monastic routine and of the wider society in which the scribes and artists lived. They illuminate and shed light upon the text, but the text also sheds light upon the visual.

Living in a different culture today, people continue to respond to the work. It is possible to see the illuminations working like any 'icon',

across the boundaries of time and culture, drawing the onlooker into the mystery of Christ, taking the individual towards what is beyond, acting as windows into eternity. They offer a sense of silence, mystery and space, even within the most vibrant designs. Some are battered almost beyond recognition, but still speak to the onlooker today, if not in the way originally intended.

The manuscript is full of energy, even in the abundant Crucifixion texts and images. This energy is depicted partly through the circular and spiral designs; partly through the great initial pages with their variety of styles; partly through the use of certain repetitive themes, such as the great beasts of Psalm 22 which rage through Matthew's Passion narrative; and partly through the playfulness of the animals that leap along the lines. There are cats running along words and a nanny goat coming home to be milked. There are peacocks, beasts fierce and playful, dogs strained to point out where the reader should continue with the text, strange contorted creatures, a prowling wolf, a cock and hens, and, everywhere, birds. Tendrils of vines pour out of chalices and olives curve along the margins. There are people too; figures with their legs entangled, though whether they are stuck or dancing is not always clear. There is a monk riding off the page (fol. 255v), his legs bare and dangling groundward, his tonsure neatly marked by the serif of the final letter of the word 'one', *unum*, on the line above. We are not told, as the script urges us to correct our sinful brothers and forgive them (Lk 17:3),[4] whether he is one of the sinners as he rides along the word *peccaverit*, 'has sinned', nor whether the horse is part of the sin or the redemption.

Some of these minor images serve as punctuation, marking where a line from a new paragraph has been raised to fill a blank space above, a convention known as 'head under the wing', which often used the figure of a bird, and sometimes another animal, facing the raised text. Some of the drawings have meanings obscure to us. Some mark short sections of the text, which may have been read aloud with long pauses to allow the listeners time for contemplation, a practice similar to the *lectio divina* of the Benedictine tradition, the reading and internalisation of the divine word by hearing and repetition. Some are pure decoration and fun, demonstrating the ability of the artists and their delight in their work.

The artistry is never static, but always seems coiled to spring as if stating that this is the creative energy of the Creator, the source of life as

known through the scriptures, and that the word of Christ was intended to bring joy. For all the rigours of monastic life, the people who created the Book of Kells clearly enjoyed their work.

Using the Book of Kells Today

Many works that have become national treasures are more revered than used, and the Book of Kells is no exception; a work of international importance that brings in many tourists from Ireland and the world. The display in Trinity College Dublin starts with an interpretative centre before coming to a raised area with low lighting like a church sanctuary, where the visitor can view it along with other early manuscripts, most especially another early gospel book, the Book of Durrow. For most, the amount of time spent with the Book of Kells is dictated by coach schedules or the pressure of other engagements. Only a few pages will ever be seen, even with repeated visits.

For those who want to spend time lingering with the images, technology can be of help. It can also enhance what the eye can scarcely see or what has been worn away over the centuries. But the way the figures and patterns on some pages seem to spring out of the vellum towards us is something that no technology can impart, nor can it capture the ways in which the use of different washes of colour make robes worn by humans and angels seem to shimmer.

It is hoped that in presenting here a number of the illuminations, together with a reflective commentary, it will be possible for others to engage with the book more deeply. The reproductions used here can only show the full-page effects of those discussed. All the pages can be viewed online at the TCD library website,[5] while Bernard Meehan's large 2012 volume *The Book of Kells* also gives many reproductions of whole pages and details, together with perceptive commentary on the content, the imagery and the practical making of the work. Other books by those scholars already mentioned and others named in the bibliography which have influenced this work, are also widely available. With a work so rich it may be enough at first to spend time with it, immerse the self in the images, and make one's own connections. Like eating a fine meal, we may not only enjoy the end product, but also find the experience enhanced by learning something about the ingredients, the length and

order of the preparation, the cooking and resting time, the presentation, *Introduction*
and then the companionship on the journey and at the meal itself. For
this we turn to the scholarship that helps us to understand the original
context, purpose and meaning, and something of the depths. From this
it becomes possible to extend our pleasure to others, to allow them to
enjoy independently and in the context of spirituality the images that
have delighted us. The Book of Kells was intended for reflection and
meditation, for the expansion of the individual's relation with God,
similar to the way in which icons can be 'windows to God' in the
Orthodox traditions of Christianity.

What Lies Ahead
This book you are reading is not a work of scholarship, though it has tried
to draw on scholarship and to have understanding enhanced by it. It is the
consequence of sitting with some of the pictures, of reading some of what
has been written by experts, and then attempting to interpret, to make
connections. Inevitably, what is derived from professional scholarship
and what are my own reflections have blended, and my interpretations
may sometimes be wrong. To keep footnotes to a minimum in a work
intended for reflection, the work of these scholars has only been
referenced in general, not in detail, but it is nonetheless respected as the
work of long hours and deep thought. To explore deeper, it is suggested
the reader goes to these scholarly works, using the 'Further Reading and
Works Cited' section as a starting point.

What follows are, therefore, suggestions only, of ways in which
onlookers today might find something similar to what Giraldus
Cambrensis, saw more than eight centuries ago, in the hope that
commentary on some of the details and intricacies may connect with
the experience and knowledge of the viewer. What is offered is intended
only as background, to aid the modern onlooker to make his or her own
connections. Scripture passages that seem to have influenced the artists
are included but they are by no means exhaustive.

Behind the decoration provided through the love and labour of the
writers and artists, there is an indication that a visionary mind once
saw how art could open the scriptures to people, in a consistent and
energising way. The person who planned this copy of the gospels wished

to indicate something of the divine purpose working out in the physical world, the Word present on the page and through the physical nature of the page's art, shown forth in new ways.

The Poetry

> *It is folly for anyone in the world to cease from praising God, when the bird does not cease and it without a soul but wind.*[6]

The illuminations in the Book of Kells are accompanied here by some poetry, in translation from Latin or from the forms of Irish written in the early Christian period and up until the twelfth century. It is not suggested that the poetry was known to the scribes and illuminators – much of it is later than their time, though a poem associated with Iona such as *Adiutor laborantium*, 'Helper of Workers', may have been composed on the island. The poems are offered here in order to assist with the making of links, as they come out of the same society with its particular understanding of Christianity, influenced by its rural and warrior culture; and the originals were composed by those who spoke a common language with the compilers of the Book of Kells.

Some of the poems are liturgical, and some are personal compositions written on the margins of other manuscripts in moments of relaxation from copying, or at times of distraction from the regular day's work. The freshness and the personal detail can speak to us, centuries later, in the same way that the illuminations speak to us visually.

They also give an additional support to two aspects of the theology of early Ireland that we meet in the Book of Kells. One is the severity of the religious lifestyle adopted by, and expected in, the monastic life. In one sense this training was as severe as that of a warrior intent on his own survival and that of his wider family. This was not only physical survival but the survival, and enhancement, of honour; an essential element of the stratified society in which they lived. For monks it was also the means by which they understood their relationship with God, the high king of heaven, the ultimate king responsible for the sanctity of the land and its harvest. It took extreme discipline, by the whole community, to produce a gospel book like this, overcoming the physical difficulties of using the materials and the spiritual discipline of learning, and understanding, the

sacred texts. This was developed through long hours of prayer, fasting and night-time vigils. There was a deep austerity in early Irish spiritual practice, an awareness of sin and a need for penitence. We get some indication of this from the liturgical poetry.

In apparent contrast, but from a Christian perception vital as confirmation of the validity of this way of life, comes an endearing aspect – the sense of fun. This is expressed in appreciation of the natural world, in being alive and through laughter. After self-denial and long hours in darkness and prayer in small cells, it is as if coming into natural light has enhanced the pleasure of life. There is a great deal of joy expressed in the illuminations of the Book of Kells, and in the poetry of the time. This is especially true in the apparently personal, spontaneous, poems but can be seen too in the more formal set pieces, translated by scholars and poets during the last century or so who have found new pleasure in them.

They show us too how much our interpretations and presentation of ancient material to others can change over a relatively short period of time. Those poems translated during the 'Celtic Twilight' of the 1890s and early years of the twentieth century are inclined to be poems in their own right. More recent translations may not attempt to produce, or reproduce, rhythm and structure, but favour more precise attention to the original meaning of the words as this has become known to us, and sometimes to the multiple metaphors that may lurk there and which, with the help of scholarship, can be recovered.

Some of the translations are well known, like the delightful poem on the flightiness of thought during prayer, or the celebration of a domestic cat, Pangur Bán. Others have only recently been brought to a wider audience.

The poetry has been incorporated into the reflections, with the intention also of displaying some of the ways they have been translated, and in the process interpreted, and how they have given enjoyment to different audiences never envisaged by the original writers.

Both the selection and the choice of translations have been made from what has delighted this writer and others. Their combination with the illuminations from the Book of Kells are offered here as a starting place for others to make their own combinations, from poetry and other works that have come down to us from the same centuries that produced this great work of spirituality. Both illuminations and poetry are known

to us, in some sense, in translation, and while it is impossible to regain what they meant to their original audiences, they can still inspire us today.

A Personal View

The Book of Kells constantly reveals itself in new ways. The reflections printed here are personal interpretations that it is hoped contain suggestions for others to explore more thoroughly the original intentions of the artists and the means they used to convey them. It is hoped that the reader will journey further with other lovers of good art and good theology. The purpose of illuminations was to illuminate the reader's own reflection on God, for these are gospel books and their artists believed that through the gospels, the story of Jesus on earth, God speaks to each individual, and also to the community.

I treat this book as an Irish work of art, though accepting that it was most probably begun if not finished on the island of Iona in the Hebrides. Now a part of Scotland, this western outpost had been settled from Ireland not many generations before Columcille, and was to him and his companions an extension of the world they knew. There was a common culture and language, and Iona was Columcille's 'place of resurrection', the place of his death where his relics were kept. This monastery was, until the Viking raids of the late eighth century onwards, the head house of the monastic *familia*, the federation of monasteries founded by Columcille. What has long been a predominantly Presbyterian island can claim to be the place where the Book of Kells originated, and its residents have stewarded the related high crosses for centuries. There is a unity in the heritage that outweighs the differences of place, time and contemporary political boundaries.

1. Giraldus Cambrensis, Gerald of Wales, *The History and Topography of Ireland*, J. O'Meara (tr.), revised edition, Harmondsworth: Penguin, 1982, p. 84.

2. Jonathan J.G. Alexander, 'The Illumination', *The Book of Kells, MS 58: Trinity College Library Dublin, Commentary*, Peter Fox (ed.), 2 vols, Lucerne: Fine Art Facsimile, 1990, p. 265.

3. See Collation diagram, Erika Eisenlohr, 'The Puzzle of the Scribes: Some Palaeographical Observations' in Felicity O'Mahony (ed.), *The Book of Kells: Proceedings of a Conference at Trinity College Dublin*, Aldershot: Scolar Press for Trinity College Library, 1994, p. 199.

4. The numbering of psalms and verses follows the New International UK Version (1984 revision) of the Bible.

5. Digital Collections, The Library of Trinity College Dublin, https://digitalcollections.tcd.ie/concern/works/hm50tr726?locale=en

6. Irish, eleventh century. Kenneth Jackson (tr.), *A Celtic Miscellany*, 1951, revised Harmondsworth: Penguin, 1971. Adapted. The original reads: 'It is folly for any man in the world to cease from praising Him …'

Part II

THE SEASONS

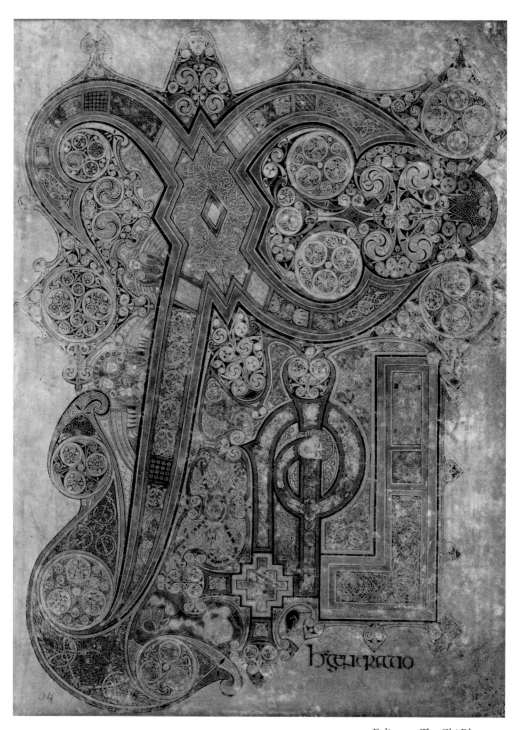

Folio 34r: The Chi Rho page

Christ was Born in Bethlehem of Judea

Let us adore the Lord,
maker of wondrous works,
great bright Heaven with its angels,
the white-waved sea on earth.[1]

 HERE IS A GRAND OPENING TO THE BOOK OF KELLS. First come pages of highly decorated canonical tables, then the *breves causae*, summaries of the gospels, accompanied by the *Argumenta*, further related material.[2] Then comes a page with the symbols of the four evangelists, next the full-page portrait of St Matthew and opposite it the full-page opening initial of the Gospel of Matthew. Matthew's gospel was at that time thought to be the oldest of the gospels, and to have been compiled by the Apostle Matthew. Its Jewish tone gave it extra authority, as the gospel as it was preached first to the Chosen People.

It opens with the genealogy of Christ and an account of the conception of Jesus. Then the Book of Kells provides a second opening. It seems that a portrait of Christ the Incarnation was followed by a 'carpet page' with a two-armed cross, and opposite it and in similar colours, though on a fresh sheet of vellum, comes the full-page initial we see above, to mark the start of the Christmas reading: 'Christ was born in Bethlehem of Judea.'

Christ was born in Bethlehem in Judea, in a certain place, with his own genealogy, in the time of the rule of a certain king, Herod, just as someone was born into Gaelic society in the eighth century, or indeed two centuries earlier in the time of Columcille. Matthew's gospel provides Jesus with all the normal aspects of a person with a family identity and responsibilities, yet this is God coming to the world, an event so momentous that it requires a full page, a new start. This page is an initial, a text page, designed to be read aloud, and shown, at the Christmas liturgy. It is dominated by the Greek

initials 'XPI', Chi Rho, the first letters of the name 'Christ', the abbreviation commonly used in Latin manuscripts of the time.

It is a page of red, with a variety of rose and purple colours, and the brilliant yellow that emulates gold. At first sight it has more in common with the carpet page that precedes it than with the portrait, but it refers to both and harmonises them. Both carpet page and portrait pages contain stylised creatures, birds with elongated necks, creatures of the earth and sea, and human beings. Here, in the apparent abstract patterns, we find that the Incarnation initial is teeming with life.

The design seems to flow spontaneously. The first letter is the huge curled 'X', a Greek letter that seems effortlessly designed freehand, the tail stretching the full length of the page, filled and surrounded with detail. It is followed beneath the second part of the 'X' by a curling 'P', the Greek 'R', which fills the middle of the page, an upright stroke spiralled over, bordered in brilliant red ink and ending in a human head. Through the centre of the 'P' is an 'I', part of the same design, and with a tail that passes through a golden cross leftwards. On the right is a rectangular panel like an 'L' backwards, again outlined in purple, and again filled with detail. These are united by lines of yellow. The design moves from the curving to the upright, and within and between the initials is artistry so fine that much of it is almost impossible to see with the naked eye. Finally, the text continues at the bottom: *h[autem] generatio*, Christ thus born.

The letters are surrounded by circles with circles within them, trefoil designs that refer to the Trinity, all drawn as if spontaneous, and as if dancing with energy. The colours match and repeat. There are the purples associated with royalty, and the central red, perhaps denoting love and sacrifice, the colour used elsewhere for Christ's clothing. The design has curled tendrils that stretch into the page's borders, as if the artist could not stop his exuberance nor let it be confined.

The subject of the page is Christ's Incarnation for the salvation of humanity. Its design speaks of the exuberance, but the apparent spontaneity has come out of artistic discipline, formed in a life of prayer and an ordered daily schedule. The page was planned in advance with geometric tools, drafted in all likelihood before that on wax tablets and scraps of vellum. The finished design was drawn carefully, and we can still see the marks of the tools on the empty back of the page.

Every circle fits within another circle, and the letters also fit perfectly. Circles and curves are repeated in ever smaller and more intricate forms, coloured separately by hand or left blank as part of the pattern. The small ones may have been done with a silver stamp carrying the minute design: the planning and careful execution is evident. Also placed there carefully by hand are red dots that highlight details. The work emulates the fineness of the metalworkers who produced items like the Ardagh Chalice in the National Museum of Ireland, which like the Book of Kells may also have been displayed and used at the great festivals.

The great 'X' curves over the page. Like a mother's arms, it shelters the human head at the centre, a cross hovering over the creation Christ has come to redeem, and over the head of Christ made human. The head is in the centre of the page. Christ is youthful, with golden-red hair and a slight beard. He does not face the onlooker directly but draws us in, as if in contemplation. There is no body but the letter is full of tiny birds and peacocks that represent Christ's resurrection, while the downward thrust of the curled 'P' outlined in red and full of interlace expands into the golden cross and continues below to become rooted in the circles at the foot of the page. Meanwhile, in contrast, the 'I', within the 'P' seems to sprout upwards energetically like new growth, broadening and carrying new designs at its tip.

The page follows the ancient tradition of Christ as blue-eyed and auburn-haired. While in the late Roman world blue eyes were at times regarded as a sign of moral weakness, they were adopted for images of Christ, presenting him as similar to other people. Auburn hair, perhaps also common, is depicted rather than the black colouring which is a sign of beauty in Gaelic secular tales. The chalk-white skin is an indication of light coming from within Christ, a northern equivalent to the icons of the Middle East, which provided more realistic brown skin through their earth-based colours, but where the interior light was indicated by painting over a thin layer of gold.

The head of Christ was apparently repainted early on in the life of the book, while the surrounding design, especially at the lower right, appears worn. It is possible that at times such as Christmas night, the community might touch the head, as an icon might be touched, brushing their clothing on the rest of the page, and in the process perhaps wearing the head away so that it required reworking.[3]

All creation is present, for the Chi Rho representation of Christ's name also represented the infinity of God, stretching to the ends of the earth. And the combination of Incarnation, salvation and redemption. On the outer side of the long first line of the 'X' three angels look on. The uppermost figure has two, or more, sets of wings and the golden hair is waving as if it has just alighted. The figure holds two staffs, symbols of office, perhaps as doorkeeper. Two more golden-haired angels, again with two or more sets of wings, have come to rest a little further down the page. They share a single halo and their inner wings, still showing some of their gold colouring, are interlinked, offering an image of the angels who hover above God's Throne of Mercy, a theme we will meet many times in this work.[4] Each holds what may be a scroll, or a long book, in one hand. They are onlookers, created beings and therefore within the patterns of circles, and within the overall design, but spiritual beings, outside the 'XPI' of the Incarnation.

The 'X' itself is full of creatures. The two parts that curve towards the right edge of the page contain panels with tiny birds, perhaps doves, facing each other. They may refer both to the Holy Spirit and more playfully to Columcille through his Latin name Columba, 'dove'. There are also elongated intertwined creatures. Similarly, the curve at the top left of the page contains within its borders more birds, arranged in groups of four, and also other intertwined creatures and abstract designs.

Angels and peacocks often appear in pairs. Peacocks are a medieval indication of the resurrection; derived from classical belief through Augustine of Hippo and others, it was believed that their flesh was so hard it did not decompose. From this they became a reference to the body of Jesus in the tomb uncorrupted and then resurrected. Peacocks, and other winged creatures of the air, are frequently drawn in elongated form, intertwining with each other and with other images, as do the snakes, the earthly representations of the redeemed human being.

Near the top left curve there are two butterflies or moths, picked out by red dots, huge in proportion to other figures, and with delicately adorned and detailed wings. They face each other, with a tiny diamond-shaped lozenge between them. They appear as an ancient representation of resurrection, indicating at the start of the Incarnation its purpose in Christ's coming to set all free from decay and bondage to sin.

The diamond between them reflects the small empty diamond at the centre of the 'X' and also the brooch worn by Mary in the Virgin and Child page to be considered later. The image occurs frequently throughout the pages, seemingly as a reference to purity, or delineating sacred space, but here it can also be seen as a chrysalis biding its time.

At the very top of the page, a human face, now faded, looks on. The figure is above and beyond the design, but part of it; and the golden-yellow outer band of the decorated edge incorporates this head. Is this the Godhead looking on at Creation and its redemption through the Incarnation? Is the page an indication of Creation in one great act of giving birth?

Underneath, in the diamond-shaped lozenge where the cross of the 'X' meets, are intertwined figures. Four are human, and they may refer to the four evangelists, the biographers of Jesus, which link the Father above and the human head at the centre of this Incarnation page. This may be one of the Book of Kells' constant reminders that the four gospels are a unity, four facets on the same story of the birth, life, death and resurrection of Christ, all serving together to link the Christian to the drama of salvation.

Intertwined with the human figures are twelve minute, fantastic, elongated birds. In many Irish saints' lives and texts that relate to scriptures, the singing of birds refers to and enhances the religious life.[5] Some birds even act as host to the souls of the dead, or recount the story of the Passion, weeping blood from between their feathers. Others sing the canonical hours and change the hearers' perception of time. They take a prominent part in the early Irish homily for Easter night, The Ever-New Tongue.[6]

The down-stroke of the 'X' also contains within it five more birds, and at the bottom of the curve there are three more peacocks, as well as vines and abstract designs. Other snake-like creatures fill the design on both sides of the letter.

Below, at the foot of the page, within the shelter of the long tail of the 'X', cats play, face to face, balancing the butterflies above them at the upper end and other side of the long sweep of the 'X'. Each cat has another creature on its back, nibbling its ears. Each also has a paw playfully extended, holding another smaller creature. The animals are united in touching one another and a circular item that lies between them, which has a cross on it.

Cats are depicted throughout the Book of Kells, sometimes in conjunction with the round eucharistic bread with a cross on it. Could they be indications of the monastic life and its contemplative aspects? From another perspective, cats were part of the domestic life of a monastery, working animals as well as pets, keeping vermin down to protect the food supplies. The smaller creatures are long-tailed, suggesting that they are not kittens, but mice.

The Last Supper, the shared meal of the Eucharist, is referred to here at the Incarnation. Harmony has broken out, between hunter and prey. The creatures are at play, and the monastic equivalents of the lion and the lamb are lying down together, with the consecrated bread bearing the sign of the cross uniting them. The artist may have had in mind Colossians 1:20, that on this night Christ is uniting all things of heaven and earth, making peace by the blood of his cross.

Also at the foot of the page, beneath the central 'P', are creatures of the sea. An otter is fishing. Christ, *Ichthys*, the most ancient symbol of the Christian faith, may be present in the salmon caught here, as Christ will be caught in time by the high priests. There may even be a reference to Irish tales of the salmon of wisdom. Throughout this book the abbreviation for the name 'Jesus', *Ihs*, is often marked by the figure of a salmon.

There are other human figures present. The final L-shaped panel contains four men, legs entangled as if dancing, two upside down, three of them apparently pulling beards, while the fourth, a youthful beardless figure, looks contemplatively away. Are these representatives of the monastic community, encouraging each to open their lips and chant the words of the psalms each day? Below them are more bird-like creatures with elongated bodies intertwined, and, upside-down, a minute chalice sprouting vines.

The design contains representatives of all of creation: as well as humans, there are birds of the heavens, creatures of the sea and the cats and mice of the land. There may be a reference in these images to the Book of Zephaniah. On the Day of the Lord everyone and everything, including the birds and the fish, will be affected (1:2-3). All the nations are involved (2:8-13). This book of the Old Testament is a prophecy of darkness and destruction, but rumours of these horrors are overturned by the Incarnation.

Christ as the Word made flesh is here portrayed coming to the onlooker out of the centre of the Incarnation page, the focus of the design, the Head of the Body, the firstborn of Creation, the Image of the Invisible God through whom all things were created, present not only for humanity but for all of the creation with which humanity is so connected.

> I consider that our present sufferings are not worth comparing with the glory that will be revealed in us. The creation waits in eager expectation for the children of God to be revealed. For the creation was subjected to frustration, not by its own choice, but by the will of the one who subjected it, in hope that the creation itself will be liberated from its bondage to decay and brought into the glorious freedom of the children of God. We know that the whole creation has been groaning as in the pains of childbirth right up to the present time.
>
> ROMANS 8:18-22

Humanity is central here. Paul's Letter to the Romans emphasises the role of the Christian as heir, the same as the freeborn son, in an inheritance that all Christians, male or female, slave or free, Jew or Gentile are to share.

> Not only so, but we ourselves, who have the first-fruits of the Spirit, groan inwardly as we wait eagerly for our adoption as heirs, the redemption of our bodies.
>
> ROMANS 8:23

The actual letters of the text appear to spring out of the page at the onlooker; the Word entering the created world, through the very vellum and ink, through the skill and love of the artist and through the beauty that links human thought across time. This book was intended to present the Word of scripture for all time, on a practically imperishable substance.

There is a link to another combination of the three letters 'XPI'. A stylised version, also found in North African manuscripts, is the ring-headed cross that was inscribed on stones in the period when the Book of Kells was made, and which reached its full development a little later

in the free-standing high crosses. The origin seems to be in the 'Christus Victor' sign found from the fourth century onwards in Roman carving, the cross surrounded by the laurel wreath of victory. The 'X' in these manuscripts was made upright and the 'P' was superimposed as a circle around the crosshead, with the final 'I' incorporated into it. In time the crosses became freestanding and carved with scenes from scripture. The stone ringed cross carries the implicit understanding of the 'Chi Rho', the name Christ, and of Christ in victory.

Some of the earliest high crosses were raised on Iona, and on two are carvings similar to an illumination of Mary and her Child in the Book of Kells. The crosses stood protectively over the monastery at the main entrances to the central sacred space, and within it, similar to the way the 'X' on this page curves over and protects the humans and their fellow creatures on this page.

In the apparently abstract design of this Incarnation page all creation is present, planned, designed and full of energy. This is a text page, which becomes comprehensible through focus on the human head in the centre of the word 'Christ'. The Incarnation is in the present, and in all time, celebrated at Christmas. The Word is present in the actual writing of the Word of scripture; present in the universe; in the labour of artistic creation as Christ was present in the labour of creation itself; and present in the lives of those who reflected this illumination, and perhaps touched it.

> I pray that out of his glorious riches he may strengthen you with power through his Spirit in your inner being, so that Christ may dwell in your hearts through faith. And I pray that you, being rooted and established in love, may have power, together with all the saints, to grasp how wide and long and high and deep is the love of Christ, and to know this love that surpasses knowledge – that you may be filled to the measure of all the fullness of God.
>
> EPHESIANS 3:16-19

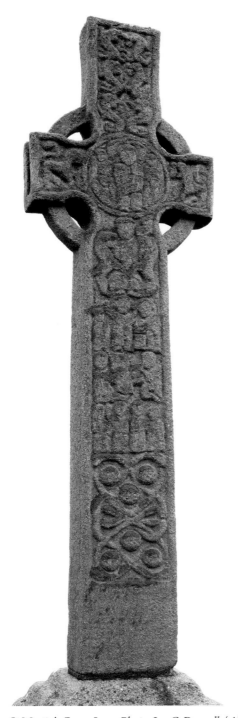

Christre was Born in Bethlehem of Judea

St Martin's Cross, Iona. *Photo: Ian G. Dagnall / Alamy Stock Photo*

The Irish poem *Saltair na Rann*, possibly from the ninth century, expresses something similar.

My King, the King of noble heaven
without pride, without boasting,
made the world with its true nature –
my King, ever living, ever triumphant;

King over the creation on which the sun looks down,
King over the depths of the ocean,
King south, north, west and east,
against whom no struggle can be maintained.

King of mysteries, who has been, who is,
before the creation, before the ages,
King living forever still, fair his semblance,
King without beginning, without end.[7]

NOTES

1. A possibly ninth-century quatrain illustrating different poetic metres.
 Gerard Murphy (ed. and tr.), *Early Irish Lyrics: Eighth to Twelfth Century*, Oxford:
 Clarendon Press, 1956, p. 5.

2. According to the Old Irish Treatise on the Psalter, these set out in simple words the
 sense of what is to follow. Kuno Meyer (ed. and tr.), *Hibernica Minora: A Fragment of
 an Old-Irish Treatise on the Psalter*, Oxford: Clarendon Press, 1894.

3. This suggestion was made by Don MacGabhann, personal communication, 2017.

4. These are some of the many details pointed out by Heather Pulliam, most recently
 in her lecture at the Arts-Iona conference, 2021.

5. See, for example, Máire Herbert and Martin McNamara, *Irish Biblical Apocrypha:
 Selected Texts in Translation*, Edinburgh: Clark, 1989, p. 9 § 2, p. 21 § 7, p. 147 § 43,
 p. 55 § 1–2, pp. 116–7 §§ 37–42 has birds. See too Martin McNamara, *The Apocrypha
 in the Irish Church*, Dublin: Dublin Institute for Advanced Studies, 1975, p. 25.

6. 'In Tenga Bithnúa: "The Ever-New Tongue"' in John Carey, *King of Mysteries:
 Early Irish Religious Writings*, Dublin: Four Courts Press, 2000, pp. 75–96.

7. Opening of *Saltair na Rann*, possibly late tenth century. Carey, *King of Mysteries*, p. 98.

✢ 2 ✢
The Temptations

Christ, Christ hear me!
Christ, Christ of thy meekness!
Christ, Christ, love me!
Sever me not from thy sweetness![1]

HE BOOK OF KELLS HAS A VIVID DOUBLE PAGE OF
illumination and decorated words to open the reading of
the First Sunday of Lent.

The liturgy here takes the account of Jesus fasting and
his temptations in the desert from Luke's gospel rather
than Matthew's, though Matthew was more frequently used across the
Christian world. Luke's was the third of the synoptic gospels, believed
to have been written by a Gentile convert of St Paul's, and was thus
significant for bringing the Good News to the Gentiles.

Folio 202v is an illustration that links the preceding text to the
following, but does not contain text itself. Jesus has been baptised
in the Jordan by John and receives confirmation of his ministry. After
this, his earthly ancestry is given, with considerable decoration. Having
rooted Jesus in time, place and kinship, the gospel continues with the
temptations, the consequences of being fully human.

> For we do not have a high priest who is unable to sympathise
> with our weaknesses, but we have one who has been tempted
> in every way, just as we are – yet was without sin.
>
> HEBREWS 4:15

The illumination links his humanity to the consequences to follow; the
preparation for the start of Jesus' ministry on earth. The great initial page
opposite, which follows this illumination, reads: *Jesus, plenum SS*; 'Jesus,
filled with the Holy Spirit …' which leads to his being led into the desert
and tempted.

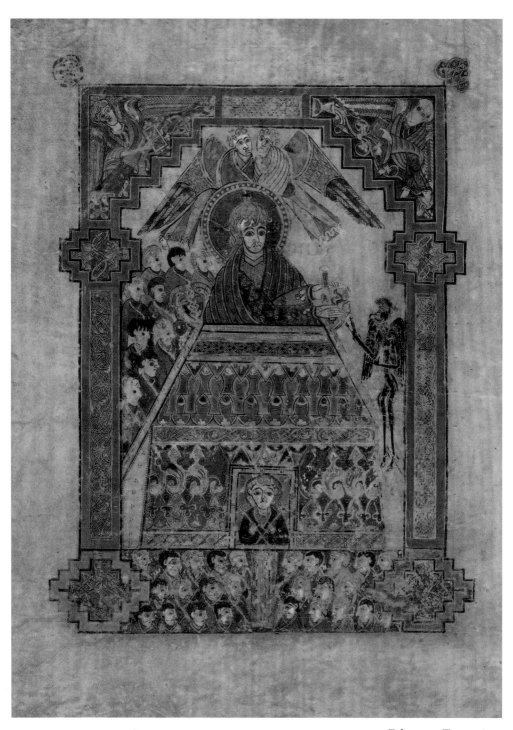

Folio 202v: Temptations

Jesus is, therefore, linked to the past, to the illuminated account of his human ancestry, and the reader is prepared by the illumination and the decorated text for the drama of the desert. In the season of Lent people fasted and reflected on the spiritual life, considering their own temptations and responses. This illumination has several layers of meaning, one of which is that, under the protection of Christ, the onlooker can be safe from all the work of the devil. It also refers, at the start of his ministry, to the cost and power of Christ's sacrifice.

The page is quite damaged and faded, and the once vivid green suffered when the book was dampened in the nineteenth century, but much can still be made out.

Luke's gospel reads:

> Jesus, full of the Holy Spirit, returned from the Jordan and was led by the Spirit in the desert, where for forty days he was tempted by the devil. He ate nothing during those days, and at the end of them he was hungry. The devil said to him, 'If you are the Son of God, tell this stone to become bread'. Jesus answered, 'It is written: "Man does not live on bread alone."'
>
> The devil led him up to a high place and showed him in an instant all the kingdoms of the world. And he said to him, 'I will give you all their authority and splendour, for it has been given to me, and I can give it to anyone I want to. If you worship me, it will all be yours.' Jesus answered, 'It is written: "Worship the Lord your God and serve him only."'
>
> The devil led him to Jerusalem and had him stand on the highest point of the temple. 'If you are the Son of God,' he said, 'throw yourself down from here. For it is written:
>
> "He will command his angels concerning you
> to guard you carefully;
> they will lift you up in their hands,
> so that you will not strike your foot against a stone."'
>
> Jesus answered, 'It says: "Do not put the Lord your God to the test."'
>
> When the devil had finished all this tempting, he left him until an opportune time.
>
> <div align="right">LUKE 4:1-13</div>

In Matthew's gospel the second and third temptations come in the opposite order, but in Luke the final cumulative temptation comes with Jesus standing on the pinnacle of the temple. The devil urges him to throw himself down, quoting Psalm 91:11-12, but without uttering the name of God. Jesus retorts, using the name of God, from Deuteronomy 6:16: 'Do not test the Lord your God as you did at Massah.'

The illumination focuses on this moment, the meeting of Old Testament and New. In the upper corners, within the external border but outside the inner, stepped border to the main picture, there are onlookers from the heavenly realms; angels with books, the sign of the New Testament, of the gospels in particular, and chalices from which pour grapes. The Last Supper and the cross are already implicit. But in the centre, Jesus holds a scroll, the Old Testament, not only rebuffing the misuse by Satan but also indicating that scripture will not be changed, but rather fulfilled.

The figure of Jesus is massive in comparison to the other figures that fill the image. He seems not so much to be on the roof of the temple but to tower up from behind it as if from behind a shrine. He wears on one arm a robe of deep red embellished with groups of three golden circles, similar to the robe worn by Mary in the Virgin and Child portrait to be considered later. The other arm also has the pattern of three circles, this time in red on a golden fabric. Jesus wears a yellow garment below, with groups of red lines, and dots in groups of three, again similar to those on his golden skirt in the Virgin and Child page. They are also like the groups of red dots on his blue garment in the full-page Portrait of Christ (page 120). They emphasise the Trinity and link the three portraits.

The green he wears in the Virgin and Child illumination is echoed here in the overall design of the page. Christ has a halo with a patterned edge similar to Mary's on that page. This is also similar to the design on the large silver paten from the eighth or ninth century found at Derrynaflan in County Tipperary in 1980, now in the National Museum of Ireland. This paten, made for the consecration and distribution of communion, is of finely worked beaten silver, with a contrasting edge of complex decoration, set with circles of millefiori mosaic glass beads.

The blue upper garment Jesus wears is like the liturgical cape worn by many angels throughout the book. Its pattern echoes the curves within

the temple below, curves that contrast the straight lines of the temple building and of the angular border, and harmonise with the curving designs within the border.

Directly above Jesus are two more angels. Dressed in translucent robes through which their limbs are visible, they are in a pose that combines contemplative stillness with movement, their wings and feet outspread, their garments flowing. Their multicoloured wings are painted in a complex, feathered manner that must once have caught the light and appeared iridescent, adding to the sense that they are in flight. They contrast with the stark, naked, figure of the tempter, Satan; described by a child as a 'dead angel', black and thin as a decayed corpse, who hovers with drooping wings and feet, alive but lifeless, one arm ending in a forked prong.

The temple itself is depicted as both the temple in Jerusalem, as in the gospels, and its earlier forerunner, the Ark of the Covenant; a smaller, transportable 'temple' which was made in the desert for keeping the stone tablets given to Moses on Mount Sinai on which the Law was inscribed.

The illumination refers to the Ark by including detail described in the Book of Exodus chapters 26, 35 and 36, on its making and furnishing. As in the description of the temple later built by Solomon, which is described most fully in 2 Chronicles 3:14, the Holy of Holies is behind a curtain made of purple, scarlet, crimson and fine (uncoloured) linen, also described in Exodus 26:31-3. Here, in the image, the curtains of fine purple linen hang in swirls in the lower part of the temple, and there are even small golden-yellow 't's that may depict their golden curtain rings. This part of the structure, when viewed as the temple also gives the semblance at first glance of being full of people, for the curling lines give this impression. The roofing of the upper part of the temple may also have had significance that is now lost.[2]

Filled with people and a door, the building is also the temple in Jerusalem. The combination of the Ark and the temple in a single image follows ancient practice, but here the combination is portrayed in a way familiar to a local audience as well. It is a small, straight-walled building with a sloping roof of the same materials. Apart from its overhanging eaves and finials, the decorative ends to the rooftrees, this is like the remaining early churches of Ireland. It is also similar to the outdoor stone shrines, which originally housed the bones of a church's founding saints. Some of these are

very simple but shaped triangularly as if roofed, like the shrines made from slabs found beside St Cronan's church in the Burren in County Clare.

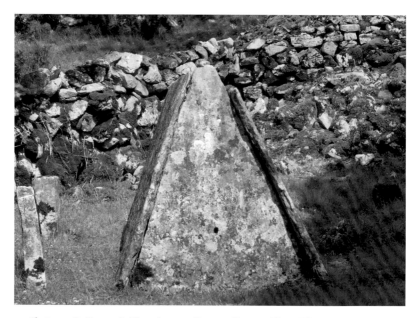

Shrine at St Cronan's Church, near Carron, County Clare. *Photo: Rosemary Power*

Other shrines are more elaborate, like the one with curving finials close to the round tower at Clones in County Monaghan. The depiction in the Book of Kells, with the overhanging eaves, may also owe much to the older timber churches that were the first buildings in the early Christian monasteries. There were, further, small portable shrines which were shaped like small churches, and which contained relics of the saints. Some have rings attached that meant they could be carried on poles in processions, like the original Ark of the Covenant.

The shrine housing the chief relics of the founder saint was a place where the saint's protection could be sought. The monasteries associated with St Columcille were under his protection, and most significant of these was Iona. The 'place of resurrection' of the saint, where his remains lay, was where others could die under his protection and rise under it on the Last Day, in the hope that this would provide their passage to a joyous eternity. It emulated the original place of resurrection, of Jesus in Jerusalem, a reminder that the household of God was ultimately under the protection of Christ.

The building we see reflects the Ark of the Covenant and the temple in Jerusalem, but also the structures derived from the New Covenant, simultaneously both a church and a shrine, in a form the onlookers would recognise.

As well as being Ark and temple, church and shrine, there is another level of expression. Christ is not depicted as standing on the roof of the temple. Only his bust shows, as a triangular form at the apex. The lines of the building continue downwards, so that he and the temple are a single unit; the temple is Christ's body and Christ is the head of the living temple. The onlooker is drawn by the image's reverse perspective along the path at the base to become part of the living temple, the body of Christ.

The psalm referred to by both Satan and Jesus begins:

> He who dwells in the shelter of the Most High
> will rest in the shadow of the Almighty.
> I will say of the Lord, 'He is my refuge and my fortress,
> my God, in whom I trust.'
>
> <div align="right">PSALM 91:1-2</div>

Christ's image forms a triangle with the temple, and the line this creates is repeated by the stepped slope of the border to the upper corners, the heavenly realm; the place of the angels where book and chalice are both visible. While the focus is on Jesus, the triangular form again indicates the Trinity.

Jesus has the freedom to jump, but uses the scriptures to defeat the temptation. In doing so he gives protection to all who come. This was emulated by Columcille and other founding saints, who in turn gave protection under Christ, especially at the place of their burial and future resurrection.

Implicit is protection in the spiritual battle described by St Paul:

> What harmony is there between Christ and Belial? What does a believer have in common with an unbeliever? What agreement is there between the temple of God and idols? For we are the temple of the living God. As God has said: 'I will live with them and walk among them, and I will be their God, and they will be my people.'
>
> <div align="right">2 CORINTHIANS 6:15-16</div>

This is also the Christ who draws all people to himself. The courtyard below the temple is full of figures with only their busts showing; giving the sense that the onlooker is among them, seeing only the upper parts of their bodies. They are waiting to see if he will jump. They may also be the tribes drawn up to Jerusalem.

> I rejoiced with those who said to me,
> 'Let us go to the house of the Lord.'
> Our feet are standing
> in your gates, Jerusalem.
>
> PSALM 122:1-2

The angels above the head of Jesus are sent to catch the Messiah should he jump as the devil urges.

> For he will command his angels concerning you
> to guard you in all your ways;
> they will lift you up in their hands,
> so that you will not strike your foot against a stone.
>
> PSALM 91:11-12

There is another level. The description in Exodus of the Ark, which contains the Law, also requires that above the Ark is the Throne of Mercy and that the images of two cherubim are made bowed and facing each other above it. The Throne of Mercy, *hilasterion* in Greek, is where God meets humanity, where blood is sprinkled in atonement for sin, putting right what has been wrong.

The Throne of Mercy above which two angels hover is here the head of Christ. He is the head of the body of the church, the temple, to which the onlooker belongs and is called to belong to more fully. Christ is the Throne of Mercy where heaven and earth meet, and humanity is put right. Christ makes this possible, the new Throne of Mercy, the interpreter of the Law through mercy.

Other, more abstract, meanings of *hilasterion* include redemption of a hostage, expiation of sin, gifts that put matters right between people. Christ is the *hilasterion*, the sacrifice that is both bread given at the Last Supper and blood shed on the cross: his halo is therefore designed like

a paten, making this connection. Christ is the gift that puts matters right for humanity, in the *hilasterion* of the temple, where heaven and earth meet; and as the bread of sacrifice. The cross is to be the new meeting place when Christ's sacrifice is fulfilled.

The figures in the courtyard are drawn towards the open door in which there is the bust of another figure. The figure has a halo like the main image of Christ above, is dressed in red, and holds two crossed staffs. Here Christ is both gatekeeper (Jn 10:7-9) and judge. Below him, in what might also be taken to be his lower body, is a path leading to the door. The reference here is to Christ the way, the truth and the life (Jn 14:6), literally the Way here. There is a suggestion of Christ as a vine (Jn 15:1-8), with the people in the courtyard acting as the branches, for green colouring twines around and between them, uniting them to the central path and central door.

The onlookers in the courtyard of the temple are the people of the present time, with perhaps a glimpse to their future in Christ's body indicated in the designs of the coloured hangings of the Ark. The courtyard stretches outwards, beyond the page, providing a perspective that includes the onlooker. The psalm quoted by Jesus continues:

> If you make the Most High your dwelling –
> even the Lord who is my refuge –
> then no harm will befall you,
> no disaster will come near your tent.
>
> <div align="right">PSALM 91:9-10</div>

There is a final group of onlookers: the nine people at the side of the temple roof and to the right of Jesus. These may represent the patriarchs and prophets who died before the Incarnation and are observing and awaiting the mystery of redemption. One of them carries a small round shield, one of several in the Book of Kells, perhaps a reference to Christ the shield, protecting the believer, an image taken from the psalms.

The eaves of the temple touch the panelled border of the image. This is clear on the left-hand side but worn away on the right, the side that has the figure of the devil. Christ hands the stark black figure of Satan the answer in scripture, but the devil cannot touch Christ, though he

is reaching towards him. The devil can enter, even into the scriptures, which is perhaps a reminder for those who copied and illuminated the scriptures that even this work can be open to deceit. It may have affected one of the early viewers passionately, for in ancient times, as modern special photography has shown, this figure was stabbed with a minute pointed object, done fiercely enough to penetrate the preceding pages.

The devil cannot enter the temple, the body of Christ, and the household under the protection of Christ. But, flaked though the painting is, we can still see that the devil has feet under the eaves. If Jesus falls, the temple falls. Jesus does not fall but responds when tempted, using the Law and the Prophets. He not only stands on the temple but he is the temple, and the onlookers are parts of the body, under his protection. Therefore the onlooker can, remaining within that body and community of faith, be safe from sin, and protected from Satan.

Satan seems a defeated, wraithlike creature for all the power conveyed by the deep black ink. His position here at the eaves of the temple may be a reference to the 'disastrous abomination' referred to in the 'last things' sections of the Gospels of Matthew (24:15) and Mark (13:14). These speak of the coming tribulations of Jerusalem, the destruction of the temple, and the need for the believer to hold fast to faith. Matthew refers the account of Jesus directly to the Book of Daniel, where a section warns of the destruction of the earlier temple of Solomon. The 'disastrous abomination; will be found on the wing of the temple' (Dn 9:27).

Satan has a foot under the eaves and a hand stretched out to take hold of the scriptures and use them, but this page is about temptation defeated. Above, in the upper corners, living angels of heaven fly with the cup and the book of the New Testament.

As in some other great illuminations in this book, there is empty space behind the main figures, vellum that was not filled in at all. The desire to embellish is met in the four outer corners of the rectangular panel, but the inside has remained unadorned. The emptiness gives a sense of space, silence and mystery that contrasts with the details and their many levels of meaning.

Nothing floats loose in the space surrounding Christ. Angels touch the stepped panel above his head, while the group of figures on one side and Satan on the other serve to attach the main picture to the border. The

eaves of the building and the courtyard with its figures anchor it on the lower side, even as the perspective opens out of the courtyard to include the onlooker. This portrait is incarnational, related to what is happening in the world, here and now, in its physical presence and supernatural quality. There are onlookers in the courtyard as well as in the heavenly realms.

There are, as always, aspects we cannot understand. One angel, in the top right corner, has an incomplete face, devoid of features. Was this deliberate, or was the figure left unfinished for some reason? The beasts on the building's gable-ends, features we associate more with Scandinavian than Irish structures, have their mouths open and their tongues red and curling, but they do not intimidate as they face each other. The human onlookers, their faces turned to Christ, remain undisturbed.

There is also the rectangular border, the inner and outer panels marked in brilliant blue, ending on each lower side in a green, stepped, cross-like form, echoing in smaller form the stepped arches to the heavenly realm. The side panels and the short panel at the top are filled with interlace. There are long-bodied creatures with beaks like birds in the cross-shaped panels on a line with the head of Jesus and in the similar crosses at the lower end, on a level with the courtyard. The longer panels hold delicate abstract designs.

At the start of Lent, the forty days of fasting that mirror the time that Jesus was tempted in the desert, the onlooker is reminded that in Jesus temptation is overcome; that he is the head, his body the temple of which all members of the household of God are part, and that all those present are under the protection of God and Columcille.

The following comes from the *Alphabet of Devotion* (*Aipgitir Chrábaid*) a work in Old Irish on the religious life. It is attributed to the nephew of Columcille; Colmán, Abbot of Lynally in County Offaly.

> Faith together with works,
> eagerness together with steadfastness,
> tranquillity together with zeal,
> chastity together with humility,

fasting together with moderation,
poverty together with generosity,
silence together with conversation,
division together with equality,
patience without resentment,
detachment together with nearness,
fervour without harshness,
mildness together with fairness,
confidence without carelessness,
fear without despair,
poverty without arrogance,
confession without excuses,
teaching together with fulfilling,
climbing without falling,
being low towards the lofty,
being smooth towards the harsh,
work without grumbling,
guilelessness together with prudence,
humility without laxity,
religion without hypocrisy,
all these things are contained in holiness.[3]

NOTES

1. Irish, eighth century, verse from a poem associated with Suibhne *Geilt*. Frank O'Connor (ed.), *A Book of Ireland*, Glasgow: Collins, 1959. Also printed in Patrick Murray, *The Deer's Cry: A Treasury of Irish Religious Verse*, Dublin: Four Courts Press, 1986, p. 22.

2. For a scholarly analysis of this image, see Carol Farr, *The Book of Kells: Its Function and Audience*, London: The British Library and University of Toronto Press, 1997, pp. 51–88.

3. Carey, *King of Mysteries*, pp. 234.

✢ 3 ✢
The Passion:
Eucharist and the Garden

It is when full of charity that one is holy.
He walks in charity.
Every evil fears him;
every good loves him.
He has honour upon earth;
he has glory in heaven … [1]

HE ARREST IS THE TRADITIONAL NAME FOR THIS picture, which is also about Eucharist and the Garden; and in which the resurrection is implicit.

The image illustrates the text not of one event but of a sequence, the words of the gospel comprehended through the illumination and the connections it makes. Further, the Word, *logos*, Christ, is brought to the onlooker as if lifted out of the text, as Eucharist. Christ is lifted high to draw all people to himself (Jn 3:14); and is also coming to meet the onlooker on the first day of the week (Mt 28:9).

It is a page of text as well as illustration, emphasising that the Last Supper, garden and cross are part of a sequence in which redemption occurs. The writing, *et hymno dicto exierunt in montem Oliveti*, 'and the psalm being sung, they went to the Mount of Olives', is part of the text of Matthew's gospel, continued from the previous page and linking it to the next.

The main figure is a youthful Christ, dressed in blue and red. He looks outward, his face surrounded with golden, curling hair, like that of the Child Jesus in Mary's arms; and with a red beard similar to the figure of Christ in the full-page portrait near the start of Matthew's gospel. The growing beardedness may refer to an understanding that Christ increased the nature of his relationship with the Father through his becoming human and through suffering. He is clothed in an enveloping cloak-like garment and a translucent full-length robe, bordered at the hems, that falls to his bare feet. Beneath it he wears wide trousers.

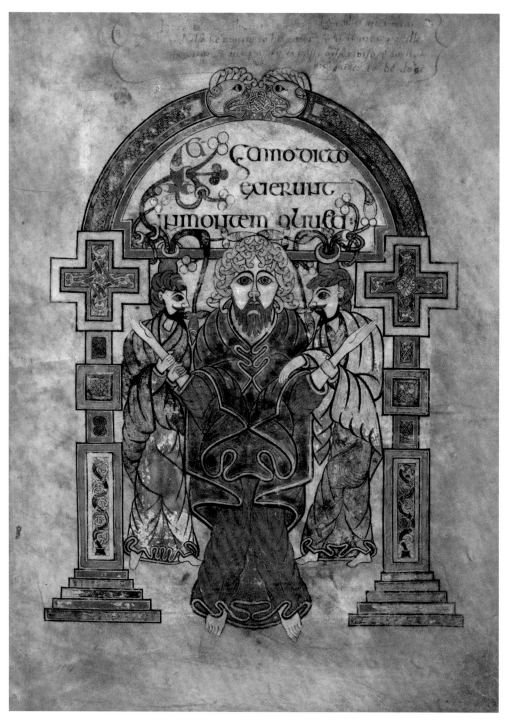

Folio 114r: The Arrest

Christ is framed in an arch with an oval head. However, the figure dominates the arch, moving out of it, towards the onlooker. Christ is much larger than the two figures on either side. His arms are held out, as if in blessing, certainly in a pose of prayer. His legs splay outwards, so that his body forms a saltire cross. He is barefoot, as are the other figures in the Book of Kells, on holy ground. He comes towards the onlooker, his feet below the level of the arch, but it seems that he is lifted up by the figures on either side. This is the moment of arrest in the Garden of Gethsemane, but it is also Christ lifted high, exalted, and brought to the onlooker.

The two smaller figures on each side of Jesus have dark, pointed beards and neatly trimmed hair. They too are in movement, in their case towards Jesus. Their faces appear only in profile, which in eastern icons disrupts the design, and is used especially to portray Judas, and the figure on the left wears a robe of dark yellow, a colour associated in later European art with the figure of Judas.[2] The other figure wears a cloak of a duller yellow colour. Their other garments are of a light blue, which appear faded in comparison to the rich colour of Christ's blue robe under the red over-garment. The two figures hold Jesus, who, though so much larger, makes no resistance, and their posture suggests reverence as much as violence.

The arch contains evidence of the garden, Gethsemane, the olive-press, with twining olives and also vines passing in front of and behind the red border that holds the text. According to Arculf, the Frankish visitor to Iona in the time of Adomnán, about a hundred years before this image was made, it was rare to find trees other than the vine and the olive growing upon the Mount of Olives. The plants are growing out of pots on the heads of the two figures, seemingly out of the figures themselves, as if they were trees. This brings us back to the reverence in how the figures hold Jesus, and may be a reference to Revelation 11:4 where two witnesses, two olive trees and two lamps are present in the temple; and behind it to the prophecies of Zechariah 4:3, 12-14, concerning the anointed who serve the Lord of the earth. The olive pots are on the heads of the figures raising Jesus from the ground, and also point to Psalm 133 and the priest Aaron.

> How good and pleasant it is
> when brothers live together in unity!

It is like precious oil poured on the head,
running down on the beard,
running down on Aaron's beard,
down upon the collar of his robe.
It is as if the dew of Hermon
were falling on Mount Zion.
For there the Lord bestows his blessing,
even life for evermore.

PSALM 133

There are also echoes of Psalm 52:8 (Psalm 51:10 in the Vulgate) which begins by complaining of those who champion evil, and goes on to declare:

But I am like an olive tree
flourishing in the house of God;
I trust in God's unfailing love
forever and ever.

The figures, barefooted, are not dressed as soldiers, or warriors, who appear elsewhere with close-fitting breeches and bare lower legs. They are robed like Jesus in an upper cloak and long flowing translucent garments. They are not solely the people arresting Jesus: they may also be seen as supporting him, their hands on the arms that Jesus has raised in blessing.

In Exodus (17:8-16) Moses raised his arms while praying at the battle against the Amalechites, and when he tired two others held his arms up for him. This was also the pose of Jesus on the cross, and the 'cross-vigil' made with arms wide while chanting a psalm or other prayer was undertaken to unite with the sufferings of Christ and as a penance for sin. Jesus is displayed on this page as also praying in this manner while at the same time may be seen as blessing those who perform the cross-vigil. There may also be hints here of the Transfiguration, when Jesus walked with Moses and Elijah on the mountain.

A further matter may be indicated in how one figure has a hand on the wrist of Jesus, and another across his upper arm, while the other figure has one hand around the wrist of Jesus and the other in front of it. They seem to be raising him from the ground.

This is a recto page, and this illumination relates to the opposite, verso page. This does not recount the arrest in Gethsemane but the institution of the Eucharist at the Last Supper, read during the Passion narrative in the week before Easter, especially on Maundy Thursday.

> While they were eating, Jesus took bread, gave thanks and broke it, and gave it to his disciples, saying, 'Take and eat; this is my body'. Then he took the cup, gave thanks and offered it to them, saying, 'Drink from it, all of you. This is my blood of the covenant, which is poured out for many for the forgiveness of sins'.
>
> MATTHEW 26:26-28

This image can be taken as the 'fraction', the breaking of the bread carried out by two priests as directed in Adomnán's *Life of St Columba* (Book 1, 44). The account of saints Paul and Anthony, early hermits in the desert, tells of how they were brought bread by a raven and divided it between them. This food brought as a gift from above echoes the story of the prophet Elijah, who was brought bread by a raven in the desert (1 Kgs 17:6), and was taken up as referring to the Eucharist. Two figures breaking bread, whether with a raven present or not, are depicted on some of the high crosses.

Here, illustrating the text of the Last Supper, the priests are holding Jesus up to view and preparing to break and give Christ to those present. Christ is offering himself to the onlooker, held up by those presiding, lifted upwards and coming forwards towards the onlooker. Like the text placed in the arch, the image presents the Last Supper, the Passion, the cross and the resurrection as a unity, all of them part of the act of salvation.

There is also a unity with what has gone before. The surrounding arch ends in steps, which may refer to the entrance to the temple. Jesus is not confined by the temple but is extending outwards from it, towards the onlooker, having broken down all barriers.

He is also lifted up and exalted. Above the steps the arch contains panels, and there are intertwined snakes in each. One in each is coloured dark, adding to the drama, balancing the sharp black beards on the two smaller figures. A black line also outlines the clothing of the figures, and of the olives.

At another level, the two figures may be taken as the false witnesses, accusers before the high priest. They may also hint at the two thieves on either side of Jesus on the cross, and this in turn harks back to their priestly roles.

Further small panels appear in the arch on each side. At a level with the head of Jesus, as in the Temptations portrait, these broaden into crosses, formed out of the arch, again containing interlaced designs. The crosses hold up the curving arch, perhaps indicating the arch of the cosmos, and the arch is again filled with intricate abstract design. At the centre are two beasts, facing each other with open jaws and intertwined tongues. The psalm Jesus begins to recite from the cross in Matthew's gospel (and completes in John's gospel) is already present.

> My God, my God, why have you forsaken me?
>> Why are you so far from saving me,
>> so far from the words of my groaning?

> Many bulls surround me;
>> strong bulls of Bashan encircle me.
> Roaring lions tearing their prey
>> open their mouths wide against me.

<div align="right">PSALM 22:1, 12-13</div>

The roaring beasts will be found again in the Passion in Matthew. The page overleaf, a decorated text page, contains at the top another roaring beast as Jesus tells his followers, 'Do not let yourselves be put to the test'. He is then arrested, and they flee.

Within the illumination there is, again, a sense of space, with vellum left blank. There is no lower border: the lower ends of the arch are open, allowing the onlooker to enter. There are no embellishments on the outside margins of the arch, nothing like the tendrils extending outward on the Birth of Jesus page; everything is contained within it. There is a connection between the arch – perhaps the temple or the cosmos – and the figures, for they touch each other and the figures touch Christ.

The illumination presents the Eucharist as the words at the Supper, the taking, blessing, breaking and giving, the consequences in the mental anguish and then arrest in the garden, and the breaking and giving on the cross.

There may also be signs of the Ascension. The two figures in pale garments on each side of Jesus may bring to mind the 'two men dressed in white' who appeared when Jesus was lifted up and disappeared from sight in a cloud, as recounted at the end of Luke's gospel (24:50-52) and more fully in the Acts of the Apostles.

> They were looking intently up into the sky as he was going, when suddenly two men dressed in white stood beside them. 'Men of Galilee,' they said, 'why do you stand here looking into the sky? This same Jesus, who has been taken from you into heaven, will come back in the same way you have seen him go into heaven.'
>
> ACTS 1:10-12

Mount Olivet, named here in the text, was taken as the place of Christ's Ascension as well as the start of his Passion. It was further taken as the place of his second coming.

> Then the Lord my God will come, and all the holy ones with him.
>
> ZECHARIAH 14:5[3]

Cross-vigils seem to have been on the illuminator's mind as he painted Jesus holding a similar pose, but coming towards the onlooker, with hands that were also raised in blessing. The blessing may have been intended to be for the ongoing work of illumination itself, for the artist and the community for which the Book of Kells was intended; and, perhaps consciously, for future generations, new onlookers from afar.

One of the additional poems, which the eighth-century monastic writer Blathmac requested read, particularly in cross-vigil on Friday night, is his lament of the Virgin. It has been suggested that the retelling of the story was based on the idea that Jesus had not been sufficiently keened on his death, and the poem is a means to complete it.

Everyone who has this as a vigil-prayer at lying down and rising for unblemished
protection in the next world like a breastplate with helmet;

Everyone, whatever he be, who shall say it fasting on Friday night, provided only
that it be with copious tears, Mary, may he not be for hell.

THE LAMENT OF BLATHMAC, 140–1[4]

… In love, holy action is found.
In holy action is found eternal life in heaven.

Love of the living God
washes the soul,
contents the mind,
magnifies rewards,
casts out vices,
renders the earth hateful,
washes and binds the thoughts.
 What does the love of God accomplish in a person?
It kills his desires,
it cleanses his heart,
it protects him,
it swallows up his vices,
it earns rewards,
it prolongs his life,
it washes his soul.

There are four redemptions of the soul:
fear and repentance,
love and hope.
Two of them protect it on earth,
the other two bear it up to heaven.[5]

ALPHABET OF DEVOTION

NOTES

1. From *Alphabet of Devotion*, Carey, *King of Mysteries*, p. 234.

2. See Andreas Petzold, '"Of the Significance of Colours": The Iconography of Colour in Romanesque and Early Gothic Book Illuminations' in Colum Hourihane (ed.), *Image and Belief: Studies in Celebration of the Eightieth Anniversary of the Index of Christian Art*, Princeton: Princeton University Press, 1999, pp. 131–3.

3. Farr, *Book of Kells*, p. 115.

4. Eighth century, Irish. Blathmac, *The Poems of Blathmac, Son of Cú Brettan*, James Carney (ed.), Dublin: Educational Co. of Ireland, 1964, pp. 46–9.

5. Carey (tr.), *King of Mysteries*, pp. 234–5.

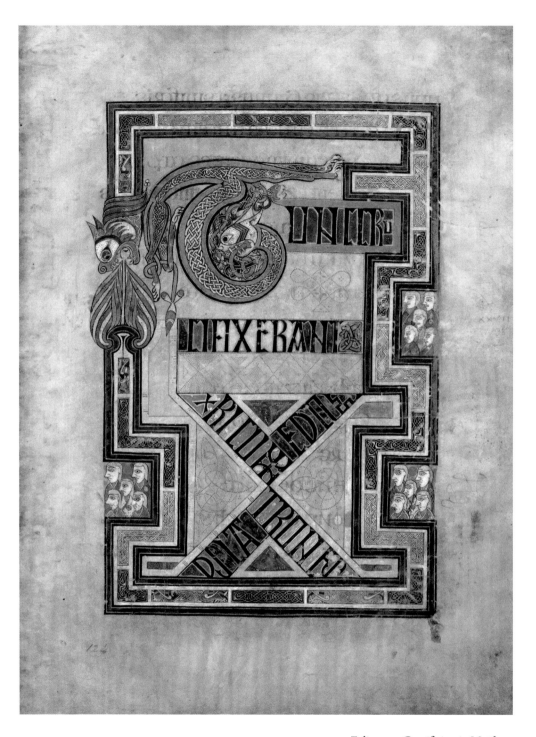

Folio 124r: Crucifixion in Matthew

✣ 4 ✣
The Crucifixion

At the cry of the first bird
They began to crucify Thee, O cheek like a swan,
It were not right ever to cease lamenting –
It was like the parting of day from night.

Ah! though sore the suffering
Put upon the body of Mary's Son –
Sorer to Him was the grief
That was put upon her for his sake.[1]

 UNC CRUCIFIXERANT XPI CUM EO DUO LATRONES. 'Then they crucified Christ [and] with him two thieves.' This page is part of the text of Matthew's gospel, words rendered as they were known, differing slightly from the Vulgate's, *tunc crucifixi sunt cum eo duo latrones*, 'then two thieves were crucified with him' (Mt 27:38).

Blue is predominant in the design, with much space left within the border where the bare vellum shows, decorated only by patterns of tiny red dots, the colour of blood. No exuberance trails over the borders of the surrounding panel. The dark blue and red are the main colours, with, at least as seen today, a more muted version than usual of the yellow colour, orpiment. Artistically, it is carefully balanced with a design of straight lines and contorted, trapped figures.

The words are in the angular script, which can herald that a passage carries pain at sight before being read, but the script is evenly sized and readable. Some of the words have been placed in the form of a diagonal, saltire cross. The opening 'T' is, in contrast to the many straight lines, rounded; formed of a beast with a gaping mouth and sharp teeth, its head turned inwards and limbs contorted, hind-feet stretched above and forefeet below. Also in the rounded centre of the letter and in danger of the beast's teeth are snake-like creatures, and a red vine, which the

beast is swallowing. Touching it is the head of a cat, trapped, stretching upwards; its mouth spouting blood in red dots.

The red dots, used in gospel books to highlight letters, have here become blood, on a page commemorating Christ's bloodshed on Calvary. There have been other, playful cats, sometimes in conjunction with the Eucharist. Perhaps they referred to seeking to emulate Christ through the monastic life. Perhaps here it is Christ who is the cat, trapped, entangled with the snakes, and among the vines from which the wine of the chalice is taken, a reference to Matthew 26:39: 'My Father, if it is possible, may this cup be taken from me.'

Another beast, a lion with a colourful roar, faces down the side of the page. Great beasts have been with the gospel for some time. They were there in the arch on the Arrest page, and again on the following page when Jesus in the Garden warned his followers that they would fall away from him (Mt 26:31).

In Matthew's gospel Jesus on the cross starts to recite Psalm 22: *Heli, heli, [Eloi, Eloi] lama Sabachthani?* (Mt 27:46)

> My God, my God, why have you forsaken me?
> Why are you so far from saving me,
> so far from the words of my groaning?
>
> PSALM 22:1

The text continues (124v):

> In the same way the chief priests, the teachers of the law and the elders mocked him. 'He saved others,' they said, 'but he can't save himself! He's the King of Israel! Let him come down now from the cross, and we will believe in him. He trusts in God. Let God rescue him now if he wants him, for he said, "I am the Son of God."'
>
> MATTHEW 27:41-43

The psalm continues, as the monastic community knew:

> All who see me mock me;
> they hurl insults, shaking their heads:
> 'He trusts in the Lord;
> let the Lord rescue him.
> Let him deliver him,
> since he delights in him' …

<div align="right">PSALM 22:7-8</div>

Then come the references we have heard before, to the bulls that surround and the lions that tear at their prey.

On this page the beasts are present. The gates of hell are open and the roaring lion dominates the page. Perhaps in the two beasts there is also a hint of Matthew's description of the two thieves abusing Jesus on the cross. The beasts give focus to a page that is also notable for its emptiness.

The snakes in the beast's jaws can at first sight seem out of place. They are found on the high crosses, especially those on Iona; though Iona, like Ireland, had no snakes. Snakes can represent a threat, an image of evil, or the 'subtle' serpent in the garden that tempted Eve (Gn 3:1). They are also a symbol of wisdom: 'I am sending you out like sheep among wolves. Therefore be as shrewd as snakes and as innocent as doves' (Mt 10:16). Matthew's gospel has the same word to describe the snake as the Greek translation of Genesis, a word that includes the sense of thoughtfulness or prudence, with the ancient attributions of medical healing.

There is also the image of the snake that sloughs off its skin which indicates renewal, freedom from sin and resurrection. This grew out of the episode in the desert of Sinai when the people of Israel were afflicted by snakebites.

> They travelled from Mount Hor along the route to the Red Sea,
> to go round Edom. But the people grew impatient on the way;
> they spoke against God and against Moses, and said, 'Why
> have you brought us up out of Egypt to die in the desert? There
> is no bread! There is no water! And we detest this miserable
> food!' Then the Lord sent venomous snakes among them; they

bit the people and many Israelites died. The people came to Moses and said, 'We sinned when we spoke against the Lord and against you. Pray that the Lord will take the snakes away from us.' So Moses prayed for the people. The Lord said to Moses, 'Make a snake and put it up on a pole; anyone who is bitten can look at it and live.' So Moses made a bronze snake and put it up on a pole. Then when anyone was bitten by a snake and looked at the bronze snake, he lived.

NUMBERS 21:4-9

The Irish poet Blathmac, writing in the eighth century, shortly before the time of the Book of Kells, refers to this passage: 'At the same time, he [God] taught them the making of brazen serpents; terror seized the (other) serpents fleeing before them (stanza 87).'

In Matthew's gospel, Jesus is the new Moses, leading the people out of the desert into redemption, making the association between the snakes and the people. The verbal links come, however, from the words of Jesus in John's gospel:

No one has ever gone into heaven except the one who came from heaven – the Son of Man. Just as Moses lifted up the snake in the desert, so the Son of Man must be lifted up, that everyone who believes in him may have eternal life.

JOHN 3:13-15

So Jesus said, 'When you have lifted up the Son of Man, then you will know that I am the one I claim to be and that I do nothing on my own but speak just what the Father has taught me.'

JOHN 8:28

But I, when I am lifted up from the earth, will draw all men to myself.

JOHN 12:32

There was also Columcille's own blessing of Iona, as described by his successor Adomnán:

> Then he raised both his holy hands and blessed all this island of ours, saying:
> 'From this hour, from this instant, all poisons of snakes shall have no power to harm either men or cattle in the lands of this island for as long as the people who dwell here keep Christ's commandments.'

Adomnán tells us that this remained in place in his own day.[2]

Jesus is thus lifted up and the cross is the focal point – with its relationship to the Wisdom of God – and draws the redeemed Christian upwards. As described by St Paul, it may have appeared particularly relevant to people from different family and social backgrounds, living together in the monastic life.

> For the message of the cross is foolishness to those who are perishing, but to us who are being saved it is the power of God … For the foolishness of God is wiser than man's wisdom, and the weakness of God is stronger than man's strength. Brothers, think of what you were when you were called. Not many of you were wise by human standards; not many were influential; not many were of noble birth. But God chose the foolish things of the world to shame the wise; God chose the weak things of the world to shame the strong.
> 1 CORINTHIANS 1:18, 25-28

On the edges there are three places where groups of figures appear within the rectangle of the design but not within the panelled border. Each group contains five figures. Perhaps they are onlookers from afar. However, in Matthew's gospel these are women (27:55), while in the Book of Kells these figures are men. Being outside the main border, they may be onlookers from across the centuries, people of the eighth century rather than the first, their faces perhaps modelled by members of the monastery. In the lower two panels there is a red circle, perhaps a

Eucharistic bread red in this place where the body of Christ was red with blood. The upper panel has four red circles on four of the figures and a tiny white circle serving to join the figures to each other.

The figures are not looking at the cruciform text, nor at the beasts, but at the opposite, verso page (fol. 123v). During the reading of the account of the Crucifixion, a double spread would be seen, of which the text page is the second half. The page towards which these figures look is blank, for the accompanying illustration to this Crucifixion initial was never filled.

The text continues unbroken from the fol. 123r to the illuminated words on 124r, showing that this was planned as a double spread of illustration and decorated text, for a central part of the Good Friday liturgy. Crucifixion scenes appear in other gospel books and on high crosses, though not on those on Iona. There is one carved on Muiredach's Cross at Monasterboice, where Christ is clothed, with arms open. A clothed, stately Christ opening his arms wide, holding them at right angles to his body is also depicted in the damaged illuminated gospel from the eighth century known as A II 17, kept at Durham cathedral. This is also the pose found in the Irish gospels kept in the Abbey of St Gall in Switzerland, which dates from around 800 CE. In each of these the risen Christ is presented, not tortured but welcoming, blessing, protecting. From the artist behind the Book of Kells something with new, profound insight might be expected. If it is compared to the Virgin and Child page (fol. 7v), to be considered later, and its accompanying text page, the small figures and the break in the border lines caused by the roaring lion would focus our eyes on specific aspects, such as Christ's hands and feet. But perhaps it was because of the disruption and violence the monastery suffered in those years that this page remains blank. Christ was still on the cross, the agony not complete, the crucifixion still taking place for the artist or the scribe or the community. Even the later owners who wrote so freely on the blank pages of the Book of Kells have left this page almost empty.

It is thought the book was started on Iona at the end of the eighth century. In the 790s Vikings from Scandinavia began to attack monasteries, and it was inevitable that Iona's turn would come. In 795 the *Annals of Inisfallen* state that they came and plundered, and in 802 the *Annals of Ulster* record that the monastery was burnt. Before more could be done, in 806 came another attack and sixty-eight members of the Iona

community were killed, perhaps fighting, perhaps resisting enslavement. The following year the building of a new monastery started at Kells, and in 814 the stone church was completed. Many of the community went with their valuables to Kells, but some remained on Iona. In 825, a year of many raids, Vikings returned to Iona with someone who could interpret, and when violence ensued, among those killed violently was the monk Blathmac. He refused to reveal where the reliquary of Columcille had been hidden, a matter recorded in a poem composed far away on the continental mainland.[3] Further attacks during the ninth century led to the movement of more relics of the saint between Scotland and Ireland.

Perhaps taking the book to Kells meant that the original plan was lost. Perhaps the overall planner died, of natural or violent causes. Perhaps this caused the hiatus which the scholar Donncha MacGabhann sees in the work of the overall artist and its decline during his second period of work. Perhaps the artists, whose work the Crucifixion scene was to be, met a violent end and had their own crucifixion at the hands of Vikings, and the page was kept blank to honour those who had suffered. Perhaps those who worked in or supported the scriptorium were enslaved, sold among strangers, transported to an unknown place from where they could not be ransomed, and their stories were lost to the monastery.

The people who began to compile this gospel book could never have imagined the arrival from across the sea of people who knew nothing of their faith, or their understanding of sacred space, of what they held dear; but looted, enslaved and destroyed. For a contemporary viewer this has many resonances in the plight of refugees and those sold into slavery, not allowed to fulfil their gifts and bound to drudgery.

Whether or not this text page illumination had been completed when the Vikings arrived, it contains hope. The border, so stark at first sight, is full of panels of interlace and also creatures, including tiny peacocks. Evil triumphs on Good Friday, but only for a short time. The resurrection is here for those who can see. Even the entangled beast of the initial letter has a three-headed olive branch for a tail.

The book's layout suggests that Good Friday liturgy was read slowly, probably interspersed with other devotions, for the following pages contain many capitals, some made of contorted beasts, allowing the reader, and viewers, to pause. On the page following the crucifixion

text, where the words are now partly obscured by the colours seeping through, we read that Christ received the insults foretold in Psalm 22 (124v), including from the temple priests. At the end of the line, looking inward to the text, walking along the word *sacerdoti* (priests), is a small peacock, with vivid blue plumage.

Perhaps this was a deliberate reminder that their own lives were not above the need for redemption. For people like them, relatively secure, at least until the arrival of the Vikings, there was still the offer of the resurrection, as there was for the chief priests who mocked sinners like themselves. It may also be a reminder that one of their number, Joseph of Arimathea, accompanied in John's gospel by Nicodemus, asked Pilate for the body of Jesus and buried it. It is in all events a sign of hope.

Psalm 22 ends:

> But you, Lord, do not be far off;
> O my Strength; come quickly to help me.
> Deliver my life from the sword,
> my precious life from the power of the dogs.
> Rescue me from the mouth of the lions;
> save me from the horns of the wild oxen. ...
> For he has not despised or disdained
> the suffering of the afflicted one;
> he has not hidden his face from him
> but has listened to his cry for help ...
> All the ends of the earth
> will remember and turn to the Lord,
> and all the families of the nations
> will bow down before him ...
> Posterity will serve him;
> future generations will be told about the Lord.
> They will proclaim his righteousness,
> to a people yet unborn –
> for he has done it.

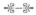

O, King of Friday
who stretched out your limbs on the cross,
O Lord who suffered for many
the wounds and the loss,
we lay ourselves sheltered
in the shade of your might;
may some fruit from the tree of your passion
fall on us this night.[4]

The
Crucifixion

NOTES

1. Early Irish. Kuno Meyer (tr.) in Murray, *The Deer's Cry*, p. 45.

2. Adomnán of Iona, *Life of St Columba*, ii, 28, and iii, 23, Richard Sharpe (tr.),
 Harmondsworth: Penguin, 1991, pp. 177, 225.

3. *Annals of Ulster* and Introduction by Sharpe to Adomnán's *Life of St Columba*, p. 83.

4. Irish folk prayer. Original printed in Diarmuid Ó Laoghaire, *Ár bPaidreacha Dúchais*,
 Dublin, 1982, no. 301, p. 102.

Folio 183r: It was the third hour

✢ 5 ✢
The Cross and the Veil

The great mountains of evil
have been cut down with spear-points:
forthwith have mountains
been made of valleys.

Though we may have evil combating
A battle with the bold devil;
To aid us, a lofty pillar,
the same Christ remains.

Though haughty are earthly kings
In robes that are brightest,
They will perish after abundance,
Each goes before another.

The fair king with piety,
Jesus over a wave of flood –
He was happily born of Mary –
abides after them all.[1]

HIS RIGHT-HAND PAGE IS PART OF THE TEXT THAT tells of the crucifixion in Mark's gospel.

Entangled words, unreadable unless known by heart, state: *Erat autem hora tertia*, from Mark 15:25. Below in red are the words: *et crucifigentes eum divise[runt]*, the last word an apparent duplication, to which we will return. Starting at the bottom of the previous page is the passage: *et crucifigentes eum diviserunt vestimenta eius mittentes sortem super eis quis quid tolleret erat autem hora tertia et crucifixerunt eum*, 'And they crucified him. Dividing up his clothes, they cast lots to see what each would get. It was the third hour when they crucified him' (Mk 15:24-25).

A full page of text and illumination, it marked a major reading. Mark's gospel was usually seen at this time as a shortened version of Matthew's gospel, written in poorer Greek: it was only in the nineteenth century that it acquired its status as the oldest of the four gospels. This is one of the few illuminations in Mark's gospel, or at least one of the few to survive. No other western text of the time of the Book of Kells uses Mark's gospel for the main readings on Good Friday: the only parallel known is a sixth-century Syriac gospel book from the other end of Christendom.[2]

We do not know why this page was a focus of the Passion liturgy or when it was used. It is impossible to interpose with Matthew's account. Was it perhaps used some years as an alternative reading? Was it read, as may happen today, on a different day of Holy Week? Luke's gospel has no special illuminated pages for the Passion, and John's gospel as it survives in the Book of Kells does not reach as far as the Passion.

Looking at the illuminated page we see three lines of black text that form a Trinitarian pattern but with jagged, distorted writing, in capital letters of varying sizes, a form that is also used for reference to the Slaughter of the Innocents, opposite the portrait of the Virgin and Child (fol. 7v–8r). The Trinitarian pattern is replicated in the elongated red lines of text below, which in contrast flow like blood. There is also an angel and parts of a human figure, but there is emptiness in the undecorated vellum between the lines of script and other matter.

The ink from the following page has come through, taking away some of the original blankness. This illuminated page appears long and narrow, the design not filling the breadth. It has none of the usual intricately decorated border, but is open top and bottom, yet intricate thought and work has gone into it. It appears incomplete, disjointed, because of the subject. Perhaps the page is meant to depict a world out of kilter, the text of scripture so disrupted that, like creation at this moment, it is disordered, incomprehensible. Perhaps only those who have the word 'written in the heart' can read it.

Only the *Erat* of the first line is easily readable, marking what is to come. The letters are entangled on the second line, and isolated and tied in on themselves like knots on the third line. As on the Matthew Crucifixion page, on this page in Mark a rounded initial precedes the angular text, perhaps identifying the normal before addressing the destruction of the normal.

The first letter ends with the head of a small lion with a golden mane that looks inward, apparently astounded. Sometimes a depiction of Christ through this king of beasts, this may be seen at one level as the lion of Mark at the most solemn moment of his gospel. The initial is filled with twisted snakes and vines. A vivid oval shape in yellow makes up the horizontal line of the 'e' and is echoed by minute golden interlacing within the rest of the letter.

The red text at the bottom has been regarded as an addition. The page may have been unfinished or a place of emptiness may have been intended. Or it may have been a link, for the text adds the words *et diviserunt* to the Vulgate. Perhaps they occurred in an Old Latin translation, but they may be part of a brief meditation or litany, perhaps one unique to the original hearers, that worked its way into their practice so as to seem part of the sacred text.[3] There are other additional words at the top of the following page: *crucifixerent eum et custodiebarit eum*, 'they crucified him, the one they had taken hold of' (fol. 183r). The first line can refer to the dividing of Christ's clothing or when, at Jesus' death, the veil of the temple was ripped from top to bottom.

The decoration is as carefully created as the script, but elements add to the impression of a disjointed world. Though there is no complete border, there are two angular panels down the sides. But nothing protects from the evil that flows through this event, from top to bottom of the page, unless it is the hidden, veiled aspect of Christ. At the bottom, in particular, the part of the book closest to the onlooker, the emptiness pours onward with nothing visual to hem it in.

Above the right-hand column, the head and bust of a man appear in the top corner. The face is youthful, with only the slightest hint of a beard. He has neat, curling golden hair, a red mantle, wears a solemn expression, and looks over towards the bottom of the verso, left-sided page, which contains the majority of the text.

The style seems naïve compared to the other figures in the Book of Kells. The head must be related to the feet seen below the hem of the long clothing, in the same red, at the bottom left of the illumination. These feet are bare, and are walking towards the middle of the page and towards the onlooker. The red garment has a different coloured hem, a style seen on liturgical garments elsewhere in the Book of Kells.

The Cross and the Veil

This youthful golden-haired man cannot be the young man, traditionally believed to be the evangelist himself, who followed Jesus to Gethsemane wearing only a linen cloth, and ran away naked at the arrest (Mk 14:51-52). This figure is clothed, in the red usually associated with Jesus rather than the purple cloak of mockery, mentioned at the top of the verso page. There are slight similarities to the depiction of the crucifixion in another book from the same period, the St Gall Gospels. There the figure of Christ appears swaddled in a large, striped garment that winds around the body. From below the feet are placed sideways as if walking. But that figure has hands where this one has none, unless they are hinted at in the small abstract patterns in red and blue, the colours of Christ, halfway down the picture on the outer side of the columns.

It seems that this is intended as a single figure broken in two, and hidden behind the vertical ornamentation with the blank space and the elaborate words separating them.

There are other figures in the Book of Kells hidden behind ornamented words. The head and feet of a human figure appear above and below the decorated 'M' of 'Matthew' in the *Argumentum*, the stories about this evangelist (fol. 12r). At the end of the genealogy of Christ in Luke's gospel, we find a similar figure behind a table (fol. 202r). The opening page of Luke's gospel has a beast that lies behind the main illumination, with clawed feet at the bottom of the page and its head at the top (fol. 188r). There is a Christ-like figure hidden behind the border of the portrait of John the Evangelist (fol. 291v). But on this page in Mark, the head and feet are divided, on opposite sides of the page.

The figure's neatly groomed hair is unlike the flowing, curling, reddish-tinted hair of Christ elsewhere. He is out of sequence with the other portrayals of Christ – the infant with the beard-line, the youthful Christ of the Christmas and Temptations pages, the full-bearded Christ of the Garden. He is also more passive, and his head is larger than normal, without the usual neck, and set on shoulders of the usual size that here appear too slender. Perhaps the figure had been partly drawn, but the head was left unfinished during the original period of illumination and because it was the figure of Christ, another artist undertook it and produced this larger head. Perhaps the Virgin and Child page influenced the pose, for Christ's eyes are directed at the words at the bottom of the verso page.

'They crucified him and divided' – according to the text they divided his clothing, but the repetition indicates another level of meaning. Perhaps this portrayal was intended to indicate Christ nailed to the cross, but calm, contemplative. It may have also been a reference to the invisible Christ. But if this is Christ crucified, the onlooker could expect to see hands, as in the portrait of St John who is upheld by the crucified but glorified Christ. Perhaps it was intended to depict Christ broken on the cross, divided as in the Eucharist. If so, it is stating, like the Arrest image, that all the parts of the Passion narrative are present in the Eucharist, in this case the nailing, the division of clothing among the unworthy, the suffering, the death and the rending of the temple veil that has divided heaven and earth.

A golden-haired angel, knees bent, hair swept on one side and wings trembling as if just alighting, holds out a book. He is dressed in a mantle over a wide lower garment, in the red and blue colours associated with Jesus. The angel is solemn, mouth turned down, another onlooker at the cross. He forms a visual link, with one wing and the body touching the panel on the left, while the other wing brushes the text, as he holds the gospel toward the onlooker. The side panels are reminders of the pillars of the temple, linking through him to the onlooker of the present.

There is emptiness behind the figure and the lines of decorated text, as if something is hidden from the onlooker behind a veil. Is there a suggestion that it is only by engaging with and untangling the words of scripture, here where the words and their meaning both appear simple but are complex, that the seeker is able to encounter Christ?

There is only one place in Mark's gospel (1:13) where angels are mentioned, ministering to Jesus after he is tempted in the desert, alone with the wild beasts. In this scene, at the last temptation of Jesus on the cross, we have one angel, and one wild beast in the lion of the initial letter 'E'. There is also a snake-like creature with legs at the end of the first line while another looks up solemnly as it forms the letter 'h' in the *hora tercia*, 'third hour' of the third line. Perhaps the first is on one level a reminder of the serpent of the Garden of Eden, legged until condemned to crawl on its belly after the Fall, unable to face the act of the second Adam on the cross. The small snakes within the *Erat* may link us to the fact that we are the redeemed who watch at the cross, but are not entirely different, and we too have fallen.

There is a link in Psalm 90 of the Vulgate (now 91) especially in verse 13. In the Vulgate this reads: *Super aspidem, et basiliscum ambulabis: et conculcabis leonem et draconem*, 'You will walk over the asp and the king serpent, and you will trample the lion and the dragon.' The lion is present here in the first letter 'E', while the creature at the end of that line might conceivably be a dragon, for which there was no direct model, or else the basilisk, the king-snake. The asp is possibly represented in the 'h'.

There is also a visual link to the Arrest of Jesus in Matthew (fol. 114r), which comes opposite the account of the Last Supper. Jesus is depicted as raised up by two priests, at the Fraction, the breaking of the bread. Here, the broken Jesus is raised up as on the cross, but Jesus is himself doing the reuniting, the head turned towards the words that tell of the Crucifixion, the feet walking towards the centre. All this happens as if behind a veil, for we do not see the body of Christ. Between the invisible God and the onlooker are the agonised, written words of the Passion. The largely invisible Christ is reuniting and healing the broken world from behind the veil.

This illumination is dominated by the bright yellow panels on either side of the page. For the original artists, the yellow orpiment was a stinking substance that must have been a penance to use. The snake-like creatures in the rectangles are gently biting each other. They may illustrate the minor resurrection, but still earth-bound condition, of the human soul after baptism, depicted as belonging to the temple of the body of Christ. The bright yellow borders appear to represent the poles overlaid with gold to carry the Ark of the Covenant (Ex 37:4), while the veil hangs on four posts of acacia wood covered with gold (Ex 36:36). The requirements for the temple in 2 Chronicles 3:1-14 similarly include overlaying the wood with gold. While in the Temptations image in Luke's gospel intended for the start of Lent, Christ's body appears in part above the temple, and later gospel books that show illuminations in which the head and shoulders of Christ are also seen above the temple.[4] There the head and feet are both visible, above and below the temple. Christ is looking over the temple, having not fallen to the temptation to jump, and has paid the consequence, but Christ is also the temple, as in the Temptations scene, and the temple is of him.

The golden yellow draws our attention on this page otherwise coloured in crimson, red, purple and dark blue. These colours also refer to

the combined Ark of the Covenant (Ex 36:35) and the temple, combined with the body of Christ, the New Covenant. In 2 Chronicles 3:14, the Holy of Holies is behind a curtain made of purple, scarlet, crimson and fine linen.

The panels of the rectangular lozenges at the four corners, joined by narrow bands of yellow, have a diamond shape halfway down. The rectangles are filled with intertwined snakes or birds, and the diamonds, little more than a centimetre wide, contain small square patterns. Within all the squares, coloured or plain, is a tiny cross, and the red squares together form a larger cross. There are further small designs protruding from the external sides of the diamonds, where the hands would be in a crucifixion scene, the only extraneous ornament in the image.

Perhaps Christ in his divine likeness is largely hidden behind the veil at the Crucifixion but will be revealed at the resurrection. Perhaps the page indicates that the veil of the temple is shortly to be rent apart as Jesus dies. The account comes on fol. 184v, preceded by one of several detailed capitals: *Iesus autem emissa voce magna exspiravit et velum templi scissum est in duo a sursum usque deorsum,* 'With a loud cry, Jesus breathed his last. The curtain of the temple was torn in two from top to bottom' (Mk 15:37-8).

This page suggests that when the veil is rent, the figure will become both joined and visible. Until then, the body of Christ is represented by the text, distorted and tortured.

The onlooker is invited to enter the temple through the golden pillars of the entrance (2 Chr 3:15-17) to the true temple, the body of Christ, and is reminded that entrance to it was achieved for humanity through the crucifixion. The veil torn at the moment of his death is taken away for all time, with the onlooker given the words of scripture, which is where the living Jesus is encountered.

The page may also have seeds of the Ascension, with Jesus returning to heaven, his body largely obscured by the cloud that covers him. The angel is then one of the two figures that appeared to those who watched, and told them that Jesus is to return from heaven in the same way on the Last Day (Acts 1:10-11).

Another detail comes from the page opposite this illumination (fol. 182v). At the end of a line, midway down the page, is a bird, its body

turned to the text, its head turned to the illuminated page. Its claws grip the word 'Golgotha', the place of the skull (Mk 15:22). It may be another link to Psalm 91 (verse 4) where God conceals us and we find refuge under God's wings.

This bird does not have the tail of a peacock, and the claws are too large. Yet there is something of the peacock about it, and the resurrection may be indicated, in the midst of the crucifixion, as it is in the minute peacocks of Matthew's Crucifixion page. An imaginative approach may link it to what Giraldus Cambrensis referred to centuries later as the 'wild peacock' then prevalent in Ireland, the capercaillie. Alternatively, the bird has some similarities to the dove, in which case it would refer both to the Holy Spirit and to Columcille, St Columba, whose Latin name means 'dove'. The claws are more like those of the eagle, in which case the links may be to Isaiah 40:31: 'those who trust in the Lord shall renew their strength, they shall rise up on wings like eagles'. Perhaps it is intended to be composite, as it turns here, linking the regular text and the full-page illumination.

Much of the page is empty. There are no flourishes at the corners, and no attempt to fill the space between the lines. It can speak to the modern-day onlooker of the emptiness of a world that seems bereft of God. It is as if a silence flows through the page, disrupted by the jagged writing that speaks of Christ on the cross. There are more references lost to a modern onlooker, and it is possible that it was never completed. But as it stands, it invites contemplation of entry into the temple, into the body of Christ, with the cross as the means by which entry is obtained. It speaks too of the resurrection, the veil rent to allow all to enter; and perhaps also of the Ascension and the second coming of Jesus.

The following lines come from a poem in Latin, *Altus Prosator*, which may have been composed by Columcille himself. It tells of the Creation and redemption, and was well known for many centuries. Each verse starts with a succeeding letter of the alphabet.

The High Creator, the Unbegotten Ancient of Days
was without origin of beginning, limitless.
He is and he will be for endless ages of ages,
with whom is the only-begotten Christ, and the Holy Spirit,
co-eternal in the everlasting glory of divinity...

The day of the Lord, most righteous King of Kings, is at hand:
a day of anger and vindication, of darkness and of cloud,
a day of wonderfully mighty thunders,
a day also of distress, of sorrow and sadness,
in which the love and desire of women will cease
and the striving of men and the desire of this world.[5]

NOTES

1. From *Félire Óengusso*, composed in Dublin c.830, *Félire Óengusso Célí Dé*, Whitley
 Stokes (tr.), Dublin, 1905; also printed in Mac Murchaidh, *Lón Anama*, pp. 81–3.
2. Farr, *Book of Kells*, p. 148.
3. According to McGurk, similar readings occur in Old Latin witnesses; for example,
 Codex Bezae, St Gallen 1394 and possibly Codex Usserianus. Patrick McGurk, 'The
 Gospel Text' in Peter Fox (ed.), *The Book of Kells*, MS 58, Trinity College Library
 Dublin, p. 117.
4. See Farr, *Book of Kells*, p. 52 for discussion of the Temptations scene and the gospel
 books associated with the monastery at Reichenau in Lake Constance.
5. Thomas Owen Clancy and Gilbert Márkus, Iona: *The Earliest Poetry of a Celtic
 Monastery*, Edinburgh: Edinburgh University Press, 1995, pp. 45, 51.

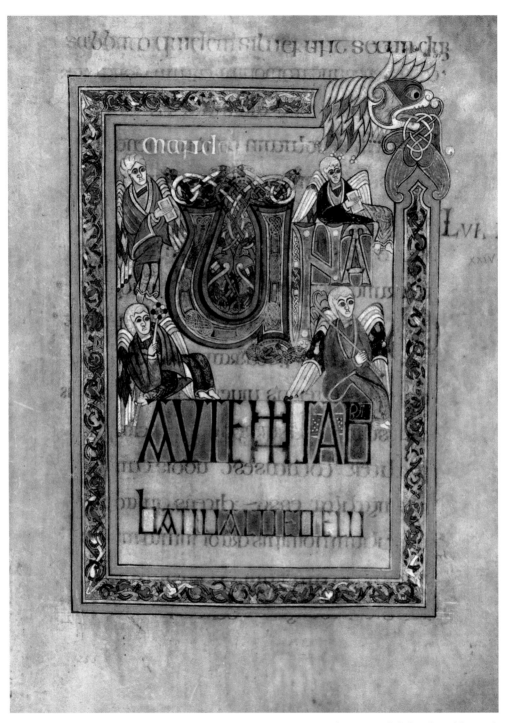

Folio 285r: Luke's first day of the week

✚ 6 ✚
Resurrection

Last night did Christ the Sun rise from the dark,
The mystic harvest of the fields of God …
The Easter joy, the threshold of the light.[1]

HE READING FOR EASTER, THE MAJOR EVENT OF the Christian calendar, comes with a decorated initial from Luke's gospel, the gospel to the Gentiles. There is no separate illustration of the resurrection, but a page with the text: *Una autem sabbati valde dilu[culo]*, 'On the first day of the [Christian] Sabbath, very early in the morning'.

The full passage reads:

On the first day of the week, very early in the morning, the women took the spices they had prepared and went to the tomb. They found the stone rolled away from the tomb, but when they entered, they did not find the body of the Lord Jesus. While they were wondering about this, suddenly two men in clothes that gleamed like lightning stood beside them. In their fright the women bowed down with their faces to the ground, but the men said to them, 'Why do you look for the living among the dead? He is not here; he has risen! Remember how he told you, while he was still with you in Galilee: "The Son of Man must be delivered into the hands of sinful men, be crucified and on the third day be raised again."' Then they remembered his words. When they came back from the tomb, they told all these things to the Eleven and to all the others. It was Mary Magdalene, Joanna, Mary the mother of James, and the others with them who told this to the apostles.

LUKE 24:1-10

The colours are light and spring-like turquoise, blues, pinks and golden yellows, as if to reflect the season of rebirth, of growth, forgiveness, festivity. Even on darkened vellum, with the ink faded and the writing from the following page showing through, the illumination still appears full of life.

The 'U' and the whole first word are easy to read, as if the resurrection is simple to comprehend where so much else is complex. It is drawn with the multiple edges that are a feature of the Book of Kells: a black outline; light blue within; followed by a slender line of black; then a band of yellow; and a black base for the abstract interlacing, a design inspired by fine metalwork. Then comes the other side of the gold border, the fine black line, the broader blue band and another broader line of black. Formed in this manner, the initial letter is picked out still further by the broad turquoise band that is part of the inner interlace. While apparently drawn freehand, and simple to execute once the basic pattern has been decided, the seeming effortlessness of the result speaks of dedication and planning.

Rising out of the 'U' as if from the tomb are twin peacocks, moving upwards out of the turquoise snakes whose heads are under their feet and whose bodies form part of the inner border of the letter 'U'. As literally as possible, these symbols of the resurrection are rising out of the word, the Word regenerating from within. They move upward towards more interlace, composed of snake-like creatures curled in a pattern that lies on the top of the 'U', taking the place of a stone, but permeable. More snakes lie at the foot of the downward line of the letter, and of the touching 'N', which has a long first line as on the decorated page of the *breves causae* of Matthew, opposite the Virgin and Child, and now at the other end of the gospel story. *Una* is both 'one' and 'first', as it is here on the first day of the week. The emphasis on the word points to the one God in Trinity, united again, on this unique day.

The peacocks from the 'U' arise to where four barefoot angels are reeling around the initial, as if stunned by the resurrection. They are reminiscent too of the guards in St Matthew's gospel who were guarding the tomb and became like dead men when the angel of the Lord rolled away the stone (Mt 27:66, 28:4). The upper angels hold books, and the one on the left indicates the 'U'. Another is sitting on the smaller letters, looking away, as if trying to take in what has happened.

The women at the tomb meet two angels in Luke's gospel, not four like in this image, but the four here make a link with the Virgin and Child illumination and the portrait of Christ, both to be considered later; and indeed indicate yet again the unity of the evangelists' four books. As in the Virgin and Child portrait, the lower angel on the left carries a round-headed *flabellum*, the liturgical staff of office, originally a fly-swatter, and the angel on the right carries a staff with curling endings, like the belled *flabella* still carried in the liturgies of some eastern Churches. The *flabellum* of Columcille had been preserved as one of the relics of the monastery.[2] Yet, there is again a puzzling feature to the angels, for the one on the lower right, who is turned away from the words, though very much part of the harmony of the image, is drawn with eyes without pupils, rendering the figure blind.

Above on this right-hand page, the beast, now tamed, roars off the page, out of this illumination and out of the book. It is golden, turquoise, blue and crimson, colours matching the other parts of the illumination, and the ends of its fur are festooned with groups of three small rings, similar to the groups on the clothing of Christ, Mary and Matthew. The elongated tongue is twisted, the teeth are now harmless, and a circle from a design below seems to have landed on its nose. This beast is colourful, unfrightening; as playful as the creatures in one of the opening canonical tables (fol. 2v), where Christ stretches out his arms while holding two beasts by their tongues. Evil, terror and death have been made harmless.

The border to the page is filled with minute creatures of all colours that gambol along, holding each other playfully with their mouths. They are intertwined not only with each other and with a thick interlinking line of deep blue, but also with vines and grapes, sometimes interspersed with chalices, the Last Supper as the way to the resurrection.

Within the main details of this resurrection page, the Passion is also present in the central line of text. The 'M' of *autem*, is written in the form of a cross with two bars, within a frame of two outer bars. The two-barred cross is the 'Coptic', 'patriarchal', cross, of the kind the Gaulish pilgrim Arculf described to Adomnán, abbot of Iona in the late seventh century. Such a cross was displayed in the *edicule*, the house over the tomb of Christ in the Holy Sepulchre church.[3] The only 'carpet page', a page of pure design in the Book of Kells, shows an elaborate two-armed

cross. This is now on the page opposite the Portrait of Christ, but was possibly originally bound the other way up (it is a single folio) opposite the 'Christ was born' initial that opens the story of the Incarnation, the 'second opening' of Matthew (33r). Here a smaller version of the cross is incorporated, embodied, in the text itself; the Word crucified but the cross empty within the word of the Resurrection account.

On this resurrection page, and as with other illuminated pages, much of the centre space is empty. When it was fresh, and before the ink from the other side came through, this emptiness would have emphasised the glow of the colours and the extent of the detail. The angels provide the unity between the main words and the border, touching both, so that nothing holds loose. There are no external embellishments beyond the rectangular border. It is as if on this page no more is needed.

The illumination of this, the first reading for Easter, does not fill the entire page. At the top, above the illuminated border, is a line of text, *sabbato quidem siluerunt secundum*, and then in red and within the border that holds the words that announce the resurrection, a single word, *mandatum*. 'Then they rested on the Sabbath, as is commanded.' These words come at the end of what is now Luke 23:56. The women who saw Jesus laid in the tomb and who prepared spices, rested on the Sabbath as the commandment decreed. This arrangement is not due to lack of space: there are only sixteen lines of text on the preceding page, leaving plenty of room for these words to have been written there. They have been placed on this sheet to make a direct visual connection: the tomb, the Sabbath and Christ's return are unified events, a story with no break in it. The last word *mandatum*, 'commanded' – literally 'handed', 'given' – actually appears within the bordered illumination for the Easter midnight reading, in the joyful colour vermillion. The women's resting on the Sabbath is decreed by the Law, but the resurrection, the artist indicates, is the Law fulfilled, as decreed, mandated, from the beginning.

The resurrection is the central message of the Christian gospels, recorded in Paul's letters, texts older than any of the gospels, written as he and the other early Christians struggled to work out the implications of the death and rising of Jesus.

For what I received I passed on to you as of first importance: that Christ died for our sins according to the Scriptures, that he was buried, that he was raised on the third day according to the Scriptures, and that he appeared to Peter, and then to the Twelve. After that, he appeared to more than five hundred of the brothers at the same time, most of whom are still living, though some have fallen asleep. Then he appeared to James, then to all the apostles, and last of all he appeared to me also, as to one abnormally born. For I am the least of the apostles and do not even deserve to be called an apostle, because I persecuted the church of God.

1 CORINTHIANS 15:3-9

While Paul's exclusion of the women as first at the tomb may jar, and the artist has got around the matter by portraying the angels as being the first to be stunned by the resurrection before human witnesses arrive, these were texts with which the monastic community were familiar as they worked out the implications for themselves, in their own lives, and in their own times. In exploring the texts and the communal theology that had led to the creation of this illumination, they might find themselves within the story of the encounter on the first morning, seeing it as happening in their own lives, communally and perhaps individually as well.

We were therefore buried with him through baptism into death in order that, just as Christ was raised from the dead through the glory of the Father, we too may live a new life. If we have been united with him like this in his death, we will certainly also be united with him in his resurrection. For we know that our old self was crucified with him so that the body of sin might be done away with, that we should no longer be slaves to sin – because anyone who has died has been freed from sin. Now if we died with Christ, we believe that we will also live with him.

ROMANS 6:4-9

We may ask how this page relates to the resurrection accounts in the other gospels. Matthew and Mark honour the events with smaller capitals, and provide readings for the season of Easter. In Matthew a full line of bright yellow announces the start of the resurrection account. This line is decorated with twining snakes, and finishes with a cat or small beast, with olives spouting from its mouth. Mark's gospel is more elaborate. The story of the Passion has already contained a number of embellished initials, many of them with snakes entwined. The resurrection starts with a similar design, but with the snakes replaced by playful cats, one of them with its head inside that of a slightly larger beast. The capital illuminations continue with designs containing cats, and there are two peacocks.

We know from the high crosses, with their depiction of the risen Christ, and from the surviving liturgical crosses like the later and highly decorated Cross of Cong (which displayed a relic of the 'true Cross'), that the suffering of Christ was not underplayed but that art emphasised the triumph of the resurrection. There are special texts in old Irish relating to the night of the Easter, in particular the Latin *Altus Prosator* from the Iona scriptorium, which is attributed to Columcille,[4] and the story of the cosmos and the place of redemption within it called *In Tenga Bethuna*, 'The ever-new Tongue'.[5]

There is no specific illustration rather than text page for the resurrection. Perhaps it seemed to the original artists that the book was so imbued with the resurrection, with the word integral to the page, and word and image so interconnected and constantly pointing in small ways to resurrection, that no specific illustration was needed. Perhaps one was planned for a single sheet of vellum, but was never completed, or perhaps one has been removed. We are left with a page of text decorated in the light colours of spring, containing humour, pleasure, energy and deep theology. The resurrection, and the journey towards a loved God, is there to change the life of the onlooker, in the colours of spring.

From the eighth century comes this well-known poem in Irish, translated by the German Kuno Meyer at the very start of the twentieth century.

I arise today
Through a mighty strength, the invocation of the Trinity,
Through belief in the threeness,
Through confession of the oneness
Of the Creator of Creation …

I arise today
Through God's strength to pilot me:
God's might to uphold me,
God's wisdom to guide me,
God's eye to look before me,
God's ear to hear me,
God's word to speak for me,
God's hand to guard me,
God's way to lie before me,
God's shield to protect me,
God's host to save me
From snares of devils,
From temptation of vices,
From every one who shall wish me ill,
Afar and anear,
alone and in a multitude.[6]

Resurrection

NOTES

1. Sedulius Scottus, ninth century, Latin. Helen Waddell (tr.), *Mediaeval Latin Lyrics*, Harmondsworth: Penguin, 1929, 1952, p. 131.
2. It was lost overboard from a boat during a storm in the twelfth century.
3. Martin Werner, '*Cructxt, Sepulti, Suscitati*: Remark on the Decoration of the Book of Kells' in F. O'Mahony (ed.), *The Book of Kells: Proceedings of a Conference at Trinity College Dublin*, Aldershot: Scolar Press for Trinity College Library, 1994, pp. 450–88, 465.
4. Clancy and Márkus, *Iona*, pp. 39–68.
5. Carey, *King of Mysteries*, pp. 75–96.
6. Eighth century, Irish, from a poem attributed to St Patrick. Meyer (tr.), part printed in Eleanor Hull, *The Poem-Book of the Gael*, London: Chatto and Windus, 1913, p. 105–6; printed in full in Murray, *The Deer's Cry*, pp. 20–1.

ENTERING
THE TEXT

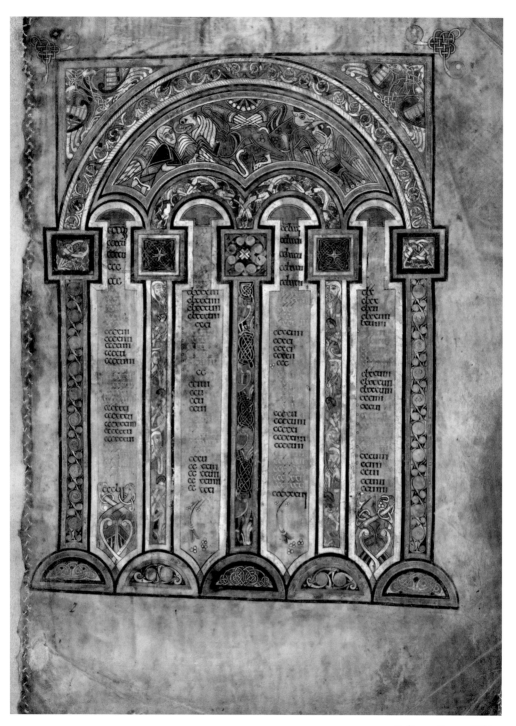

Folio 2r: Canon Tables

✝ 7 ✝
Canon Tables and Evangelists

Come into my dark oratory,
be welcome the bright morn,
and blessed He who sent you,
victorious, self-renewing dawn.

Maiden of good family,
Sun's sister, daughter of proud Night,
ever-welcome the fair morn
That brings my mass-book light.[1]

HE BOOK OF KELLS OPENS WITH A LIST OF HEBREW priests, accompanied by the symbols of the four evangelists (fol. 1r), followed by the canon tables set in a series of elaborate arches. The arches are supported by pillars and the upper corners are filled to provide a rectangular scheme. These are followed by two pages of tables; then comes the portrait of the Virgin and Child; followed by preliminary matter common to the great gospel books, summaries of the gospels and pointers to focus the mind, the *breves causae* and the *Argumenta*.[2]

Each of the four gospels was intended to be preceded by a page containing the symbols of the four evangelists, unified by an upright or a saltire cross. Then came a portrait of the writer of that particular gospel, followed by a full-page opening initial. While most of this follows the pattern of earlier continental tradition and of other insular gospel books, in the Book of Kells the designs are, as we have seen, exceptionally rich, and have a sense of physical depth. The same traditions produced the book-shrines made of precious metals in which significant books were preserved from damp and rodents. The box-like shape of some of the designs further gives the impression of a book-shrine, which the reader will proceed to open.

The canon tables, intended to help the reader find parallel passages, are mostly presented in classical arches, as if they were the portico of the temple, the entrance to the courts of the Lord, the gospels. The onlooker may be seen as going up with the psalmist to Jerusalem.

> I rejoiced with those who said to me,
> 'Let us go to the house of the Lord.'
> Our feet are standing
> in your gates, Jerusalem.
>
> Jerusalem is built like a city
> that is closely compacted together.
> That is where the tribes go up,
> the tribes of the Lord...
>
> Pray for the peace of Jerusalem:
> 'May those who love you be secure.
> May there be peace within your walls
> and security within your citadels.'
>
> For the sake of my brothers and friends,
> I will say, 'Peace be within you.'
> For the sake of the house of the Lord our God,
> I will seek your prosperity.

<div align="right">PSALM 122</div>

The onlooker moves through the arcades towards the text, the holy centre. This is protected space, for the reader and perhaps even more for the writer and artist, those who were responsible for transmitting the content to future viewers and readers.

There are regular threefold designs, representations of the Trinity. At the base, the pillars touch each other and, like the outer pillars, are filled with the interlace that ensures there is no unprotected entrance through which evil might enter. There are peacocks and other elongated birds within the arches, sometimes minute, almost always intertwined. No space except the text space is empty. These pages are to delight the eye,

to impress and to instruct. Overhead, on two of the pages, Christ appears. In one (fol. 2v), Christ is pictured with a black beard (perhaps added on later) and his arms wide, holding two beasts by the tongue. They prefigure the beasts of the Passion narrative in Matthew, and the colourful beast of Luke's resurrection page. There is also a reference to a vision of the prophet Habakkuk, popular in the early Middle Ages, that speaks of Christ crucified between two beasts. On the facing page (fol. 3r), Christ appears above the arches, within a sacred circle, wrapped in a priestly cope.

Within the circle of each of the arches on these pages, holding up the heavens, are the symbols of the evangelists, touching each other, and on every page in a different pattern. In each page there is the contrast between the formal, classical design of the arches, and the sense of energy and movement produced by the figures.

The Eusebian canon tables identify the passages found in more than one gospel (just as chapter and verse provided reference in later times), and thus present four gospels as a unity. Unity was constantly emphasised by the artists of this book, who give the symbols of the evangelists united artistically, visually supplementing the written tables. But the tables here are practically useless, for they were never accompanied by the marginal numbers in the texts needed for reference. The Book of Kells was not intended for close textual study, but for another kind of illumination, of enlightening the onlooker.

On the page in question here, fol. 2r, the script is scarcely noticeable beside the arcade and its rich embellishment. Some at least was added after the design was completed and overlaps with it. It is in a pleasing, clear hand, in black and red ink, but this is not sacred text, and the illumination can, and does, dominate.

The arcade on this page includes four smaller arches at the head of each column, within the overall arch. The two in the centre are larger and give a sense of space, even though there is no actual perspective. The onlooker is drawn in as through the arches.

The evangelists' symbols occupy this space in the central arch. They originate from the four 'living creatures' that draw the throne-chariot of God, in the vision in Ezekiel (1:4-12); forerunners to the creatures in the Book of Revelation (4:6-9) that came to represent the evangelists, who are prefigured in and are fulfilling the prophecies of the Old Testament.

Meanings accrued to the symbols over centuries and they came to represent not only the evangelists, but also the nature of Christ, and then the Christian virtues required for salvation. Matthew is represented by a winged man, or angel. Matthew's gospel starts with Jesus' genealogy from Abraham so it can be taken as representing Jesus' Incarnation and Christ's human nature. Mark takes the form of a lion. This is a figure of kingship but also courage, for example in Mark's representation of John the Baptist preaching at the beginning of his gospel. It also represents Jesus' resurrection, for lions were believed to sleep with open eyes, and so were comparable with Christ in the tomb. Luke's symbol is an ox or calf, a figure of sacrifice and strength. Luke's account begins with the duties of the priest Zachariah in the temple. The symbol can be taken to represent Jesus' sacrifice in Passion and Crucifixion, and Christ as high priest, a role of service and sacrifice. John's representation is an eagle, a figure of the sky, believed to be able to look straight into the sun. John starts with an eternal overview of Jesus the Word and takes an approach to his ministry that emphasises Christ's divine nature.

The symbols were shown in early medieval gospel books, sometimes accompanying a portrait of Christ in Majesty, referring to the vision in the Book of Revelation. The evangelists were often depicted in buildings, especially at entrances and at apses, and winged, as in Ezekiel. It seems too that the Irish Church was aware of the ancient ceremony for catechumens of *apertio aurium*, the opening of the ears, in which the four gospels and their evangelistic symbols were individually displayed and explained.[3]

This page conveys both the solemnity of the scriptures that are to be opened, and also another enduring trait of the Book of Kells: its sense of fun. The lion of Mark is about to lick the face of the man. Its wing links with that of the ox, whose figure turns towards the eagle, its tail swinging over its head. Creatures that may be enemies in the natural world are here interlinked and at play.

Above the main arch, in the corners, there are on each side two peacocks, their bodies facing each other, their heads turned over their shoulders, elegantly fitting into the space, with an interlaced design accompanying them. The arch is filled with tiny interlocking snakes and vines with three-fold leaves. Interlocking peacocks also appear in the spaces below the numbers of the canon tables, and vines entwined

gracefully around the necks, which cross over each other as they rise upwards. The spaces in the two inner columns contain more delicate tendrils of vines. Yet more peacocks, with abstract interlace between them, rise up within the central pillar, picked out in the light blue that gives lift to the page. Abstract design fills the outer pillars but the two outermost of the square blocks at their heads contain more entangled snakes and vines.

As well as the peacocks and the snakes, which are their earthbound equivalents, humanity is present. Also rising upwards, legs entangled and accompanied by more vines, are the figures of three men in each of two of the pillars. The purpose of the scriptures, the cross and the resurrection, is presented here as these figures climb upwards towards the heavenly realms portrayed in the arch of the temple, where the winged, angelic symbols of the evangelists are at play.

Some of the human figures are pulling their beards. A common visual theme in the Book of Kells, there are often two figures sitting with legs entangled and pulling each other's beards. Occasionally this can suggest strife, but in other places, like the page with the evangelists' symbols in Matthew's gospel (fol. 27v), the four beard-pullers in one corner seem to balance the four figures holding books in the opposite corner. Here they pull their own, and similar figures pulling their beards appear in the columns of the preceding page to this one, with the exception of the lowest half-figure in the left-hand column, a beardless youth with his arms by his side (fol. 1v).

Perhaps this strange motif refers to the Vulgate's *Domine labia mea aperies et os meum adnuntiabit laudem tuam* (50:17), 'O Lord, open my lips, and my mouth will declare your praise' (now Psalm 51:15). From early times this was used (often in plural form) as the Invitatory, a brief opening prayer and response, at the start of the hours of common liturgical prayer. The Rule of St Benedict specifies its use. Here they are literally opening their lips, or more often each other's lips by pulling on the beard. Their prayers may perhaps be intended as pillars holding up the church of believers.

A modern viewer can delight in these pages, but may wonder why so much time was given to extraneous matter. The provision of the Eusebian canons at the start was the normal pattern adopted from the Continent, but here it was taken to new heights, even before the text itself is reached.

Perhaps there is something here of the nature of a book for the original viewers, the product of much work which was intrinsically linked with their life of prayer. While some early Irish poets wrote, sometimes on the margins of works they were copying, of the sweet life of the scholar, the actual making of a book was a lengthy and messy process requiring many skills and the labour of the community.

The monastic community had first to acquire cows in calf and select those newly born suitable for slaughter. There was then the skinning, cleaning, scraping, soaking, liming, stretching, drying, whitening, cutting and finally ruling for ink. The ink was made from soot or oak-gall, while colours were produced from a mixture of plant, marine, non-organic and sometimes stinking and dangerous substances – many local, some imported – and the process was lengthy and messy. Eggs also needed collecting, for use in fixing the colours, as did fruits for the making of glazes.

A potential scribe had to learn to recite the scriptures, then to read them, and then to develop the more difficult task of writing, in a hand that others could read aloud in a dark church, and the script had to be checked for errors by another writer. As part of the labour of the monastery, it may be assumed that these acts were also taken as prayer, work that was intended to deepen and pass on the understanding of the Word of God.

Producing a book was slow and laborious, but for scribes emulating their founder, Columcille, a noted scribe who lived in the years when Christianity was new and books were rare and scarce, it seems to have been a joyful life. An early-twentieth-century translation by Robin Flower of a short poem on the pleasures of writing out of doors, reads:

> Over my head the woodland wall
> Rises; the ousel sings to me.
> Above my booklet lined for words
> The woodland birds shake out their glee.
>
> There's the blithe cuckoo chanting clear
> In mantle grey from bough to bough!
> God keep me still! For here I write
> A scripture bright in woodlands now.[4]

This appears to be a spontaneous outpouring by someone in a smaller monastery, doing the same, if less elaborate, work, in natural light, on a clear day. It has been pointed out, though, that the text has layers of imagery, of writing in a small field, enclosed within a protected space, of doing the labour that is part of the natural round of this kind of life.

The Irish shows the form Flower tried to retain.

> *Dom-farcai fidbaidae fál*
> *Fom-chain loíd luin – luad nad-cél*
> *Húas mo lebrán ind línech*
> *Fom-chain trírech inna n-én.*

A literal translation by the scholar Cathy Swift displays the layers, though not the form.

> The hedgerow guards me – the blackbird sings a lay to me – a story which is not hidden: above my little book, carefully lined, the birds sing a melody softly.

> The stammering cuckoo in a grey cloak sings softly to me – a lovely cheerful sound – from the security of the bushes. By God, my Lord is cherishing me, as I write fair beneath the cries of the home-woods.[5]

With regard to the Book of Kells, the work on something this large and elaborate involved comparison with other gospel books and the designs used by others; as well as the creation of new designs and the act of teaching them to others.

It is stated that the book that Giraldus Cambrensis saw at Kildare must have been written by angels in the time of St Brigid. This may relate to the way in which angelic symbols of the evangelists are sometimes portrayed in gospel books as dictating to their evangelist, just as an angel came to the prophet Isaiah (Is 6:6) to purify his lips to make them fit to preach, using a live coal. Similarly scribes, monastic men and in some places women, could be prepared to write the Word of scripture.

It was later believed that the Book of Kells was written not by angels but by Columcille himself. A book written by a saint was a relic, even a

less elaborate book. His successor as abbot, Adomnán, relates that books written by Columcille and also the white tunic he died in were taken around the fields of Iona during a time of drought. The books were read aloud, and these actions led to a good harvest.[6] The eighth-century Book of Durrow was later dipped in drinking water to keep cattle from sickness. The Cathach, a psalm book thought to be written by Columcille, was revered for centuries in Donegal and was carried in its shrine around the assembled warriors before battle. The Book of Kells itself, though at different times stolen, used for charters, for a poem, for later scribblings and experiments, was revered enough to survive, even in a battered state.

One of the most delightful poems in medieval Irish is placed in the mouth of a monk, who in old age is reunited with the love of his youth; who travelled with him, slept with him and then slept with other men. She continues to be the source of his wisdom and pleasure. This is the psalter he learnt from in his youth addressed in the language of courtly love. A translation made by the poet Frank O'Connor made in the middle of the twentieth century, a time of rigorous censorship in Ireland, escaped condemnation in view of this interpretation.

> You are a token and a sign
> To men of what all men must heed;
> Each day you make your lovers know
> God's praise is all the work they need.
>
> So may He grant me, by your grace,
> A quiet end, an easy mind,
> And light my pathway with His face
> When the dead flesh is left behind.[7]

> What should a man learn?
> Not hard to answer:
> constancy in holiness,
> shortness in words,
> gentle brotherliness,

smoothness in giving ...
The fifteen virtues of the soul:
the virtue of faith,
the virtue of gentleness,
the virtue of humility,
the virtue of patience,
the virtue of mortification,
the virtue of obedience,
the virtue of charity,
the virtue of truth,
the virtue of mercy,
the virtue of generosity,
the virtue of forbearance,
the virtue of brotherliness,
the virtue of moderation,
the virtue of holiness,
the virtue of almsgiving ...
The body shelters the soul.
The soul shelters the mind.
The mind shelters the heart.
The heart shelters faith.
Faith shelters God.
God shelters man.[8]

NOTES

1. James Carney (tr.), *Medieval Irish Lyrics*, Dublin, 1967, reprinted with *The Irish Bardic Poet*, Dublin: Dolmen Press, 1985, pp. 80–1.

2. For *Argumenta*, see Kuno Meyer (ed. and tr.), *Hibernica Minora*, 245–55, www.ucd.ie:80/tlh/trans/km.hm.001.t.text.html

3. Éamon Ó Carraigín, '"*Traditio evangeliorum*" and "*sustenatio*": The Relevance of Liturgical Ceremonies to the Book of Kells' in O'Mahony (ed.), *Book of Kells*, pp. 398–430.

4. Flower (tr.), printed in Murray, *The Deer's Cry*, p. 32.

5. Cathy Swift (tr.), 2010, unpublished. Used with permission.

6. Adomnán, *Life of St Columba*, ii, 44, Sharpe (tr.), pp. 199–200.

7. O'Connor, *A Book of Ireland*, pp. 366–8.

8. Carey, *King of Mysteries*, pp. 235, 239, 240.

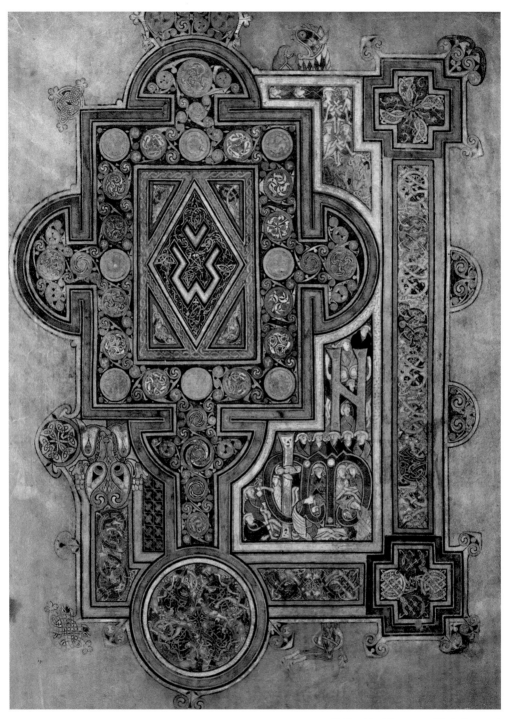

Folio 188r: The start of Luke's gospel

✠ 8 ✠
The Start of
Luke's Gospel

Learned in music sings the lark,
I leave my cell to listen;
His open beak spills music, hark!
Where Heaven's bright cloudlets glisten.

And so I'll sing my morning psalm
That God bright Heaven may give me
And keep me in eternal calm
And from all sin relieve me.[1]

ACH GOSPEL BEGINS WITH AN ILLUMINATED PAGE containing the opening words, and these initial pages create a sense of unity, though each one is different. The great initials contain, amidst all the elaboration, the actual opening words of the gospel in question. But they have to be searched for: the Word of God is not only to be heard, but its meaning must be sought. Luke's initial page is a design of rectangles, circles and spiral patterns, predominantly in deep blue combined with shades of red and golden yellow. Within it are contained thirty human figures.

This gospel was written by a Gentile, traditionally regarded as a doctor, who St Paul befriended in Macedonia. He addressed his gospel, and the Acts of the Apostles, to one Theophilus, 'lover of God', as if to a person of some eminence. Based on this understanding, it is suitable, therefore, that the gospel opens with a stately square capital in classical proportions, which fills the page.

A small human figure is present near the top right of the other gospels' initial page. In Matthew's gospel a man with a book looks on mildly. In Mark's a man is playfully holding the elongated tongue of a lion, Mark's symbol, with which he is entangled. In John's gospel a figure sits in peaceful contemplation, drinking from a chalice, while a fierce beast with sharp

teeth faces him, his tongue uncurled but unable to touch him. In Luke's gospel there is a strange elongated beast with open jaw, its head appearing at the top and its clawed feet at the lower margin of the page. This black-and-white beast is more badger than lion, and certainly not an ox or calf, the symbol of Luke. Beside its head there is an unfinished human figure, much smaller than those in the other initial pages. The body is drawn at an angle that suggests the missing head should be in the mouth of the beast, echoing the actions of two figures within the main design.

This gospel opens:

> Quoniam quidem multi conati sunt ordinare narrationem quae in nobis conpletae sunt rerum.
> '[Since] many have undertaken to draw up an account of the things that have been fulfilled among us…'

Only the first word, *Quoniam*, 'Since', 'In as much as', appears on this page. Those who could both read and already knew what to look for, could find it. It is best found by reading backwards from the smaller, more legible, final letters of the word.

The design dominating the page comprises a huge 'Q'. It is a square letter with half-circles added to give it a rounded shape, and a tail which culminates in a large circle on the same scale as the half-circles. Below and to the right, the tail carries on, and culminates in a circle as the same form as the half circles of the 'Q', then joins to a border filled with snake-like creatures in the same colours and to the same scale as the designs which fill the 'Q'. The many bordering lines in different colours and the skill in execution make this one of the pages that seems to be three-dimensional. In a *trompe l'oeil* effect that has survived the damage and use of centuries, some of the letters and surrounding borders appear to be at different heights.

The next two letters are hidden within the 'Q'. The red square in the centre contains a diamond, a form elsewhere used for the 'O' (and to mark sacred space), and the two together form the third letter of the word. Within them the angular golden letters, also doubled, form the preceding 'U'. To read these letters, then, we then need to extract the 'Q' from the designs it contains, and then search within it for the third letter,

and within that for the second. The reader needs to know their letters, and where to look for them, before they can enter the text.

The 'N' is much more easily decipherable, in red to the right. Below, a golden 'I' can be seen entangled with the next letter, 'A', in the 'a' from, which is attached to the following 'M'.

The 'Q' appears like church architecture. One possibility is that it is based on a description known on Iona of the Holy Sepulchre church in Jerusalem. In the 680s, about a hundred years before the Book of Kells was composed, we are told that a Gaulish monk, Arculf, visited Iona and gave an account of the holy places to the abbot Adomnán. Arculf sketched the plan of the Holy Sepulchre, which Adomnán copied, and he then wrote a book, using the information passed to him by Arculf. The English writer Bede knew of the visit and the resulting book. A ninth-century continental text of Adomnán's book contains a drawing of the Holy Sepulchre floor plan, a circular building that has three semi-circular apses, and is connected to a rectangular building. Inside the circular building, the church built by St Helena and her son, the Emperor Constantine, in the fourth century is shown, the small rectangular *edicule*, the 'little house', formed around the rock tomb of Jesus.

If a plan like this is behind the design of this page, it may be that the circular extensions, which give the rounded shape to the 'Q', are based on the apses. The design may be based on some other church, seen on travels abroad, or described by someone who had made such a journey, but there is a general resemblance to descriptions of the church at the heart of Christendom. This contained Calvary at one end of the structure and at the other the large circular church of the resurrection, within which stands the embellished tomb of Christ.

The diamond shape forming the centre of the 'Q' relates to the diamond shapes found elsewhere; the brooch on the breast of the Virgin in her portrait page and the two diamond shapes on the Birth of Christ page. Whether these have a similar role to the oval *mandorla*, the holy space in eastern icons, or whether they represent purity or harmony associated with the Virgin and with the birth of Jesus, it appears at the opening page of the gospel most associated with Mary.

Moving from the stately form to the images brings a sharp contrast. The last letters of the word *Quoniam* are set in a panel packed with

twenty human figures. They have lank golden hair and all are involved in activities that seem far from the monastic ideal. Above the 'N', two are looking dully outward. Two others are hanging, each with an arm up, heads sagging at an awkward angle inwards, feet dangling helplessly, their bodies almost naked, as if they have been hanged. Below, another figure looks outward, off the page, apparently aghast. Then comes a row of five men, above the 'M'. Two look inwards from one side, and the other three inwards from the other. Some of their hair has been tangled together, as if in parody of an interlace pattern. They are clothed, in red, green or blue cloaks, each one edged in an attention to detail that contrasts with their activities. At the left within the 'M', two more men wear cloaks but have their naked legs entangled and their arms engaging with each other, while to their left another glumly looks their way, hair tangled before his face as if damp. Below, the 'M' ends in the heads of beasts, their jaws open to receive the heads of two more figures. These sit bowed, naked legs entwined, mantles around their shoulders, each with a hand that is not fending off the beasts but holding foliage. They are perhaps, for better or worse in their chastened state, hanging on to the vine. They are very different from the incomplete figure above the upper border, with its head positioned for the mouth of a beast, and also from the figure on the initial page of John's gospel, who sits serene before the jaws of a beast.

To the left another, bare-legged, figure is bent over the 'I' as if retching, and to his side another figure turns away to pass a bag or a ladle to a sitting figure who loosely holds a cup, and whose legs are entangled with those of a gloomy figure lying almost prone. These last two are outside the initial letter of the word, yet within the protecting panel. If they are thieves, these two outsiders will hardly make a getaway with legs so entwined. If they are receiving from the clothed figure, it is conceivable that they are indeed outsiders, pilgrims receiving the cup of hospitality. Alternatively, they might be the wealthy who stored their treasures at the monastery being given back their due, but if so this is being done surreptitiously while the community is distracted. Perhaps there are hints that the onlooker should not store up treasure in this world where moth and rust can get in, even in a monastery.

Whatever is happening, the design is discordant with the form of the page, with its skilful design of a word to be read from within. The immediate

response is that they are twenty drunk, or at the least hungover. Perhaps the obvious is intended. It may be a comment on the drunken feasts at the court of kings. It may record an occurrence within the monastic community, for all the faces as well as the poses are different and there is a chance that this refers to a party and its consequences. There is an early Irish manuscript where the scribe has written in a margin the single word, in ogham script, 'hangover'. Hangovers seem to be only too real in this picture, with two chastened souls putting their heads into beasts' mouths.

There *may* be a link to Luke's other book, the Acts of the Apostles, to the account of Pentecost when it appeared to listeners that the apostles were drunk with new wine (Acts 2:13), but the figures here have been depressed rather than stimulated to preaching, and at least two are acting in disobedience to monastic chastity. It is perhaps a reminder of the fact that all the artistry, however perfect, is all for frail human beings. There may be a reference to the life of the early church where all the believers had all things in common (Acts 4:32-5), but these are generous interpretations. Another possibility is a link to a passage written twice by the scribe a few pages later (fols 218v and 219r), of which the first version was cancelled by another hand. This is the account in Luke chapter seven of the 'woman who was a sinner' who came into the house of Simon the Pharisee, and wept over Jesus' feet. If it is not a genuine error when two manuscripts were being made, could it be that the repetition of this passage reminded the first onlookers that all in the monastic community were sinners in some form, and this was captured visually in the design of the opening, initial page?

It may be, however, that both these drawings and the design of the main word refer to Adomnán's book on the holy places. Arculf describes the huge basilica on Mount Sion, which covers the spot where the first martyr, Stephen, was stoned to death, a church that also contains the rock against which Christ was scourged. In contrast, there is also on Mount Sion, he says, the place where it was believed Judas hung himself in despair from a huge fig tree; and a small plot of ground enclosed with stone, where many pilgrims receive careful burial, but where 'others are carelessly left lying on the face of the earth in a state of putrefaction, covered by mere rags or skins'.[2] If this is the obscure image behind the illumination, it suggests that the debauched who fail at the monastic life

are like those who are exposed to the elements and to all vices. They are like Judas hanging, naked like the putrefying corpses as they engage in despair, debauchery, gluttony, theft, sloth and factions, to name some of the sins against the Spirit named by Paul (Gal 5:19-21), which prevent people from inheriting the kingdom of God.

Whether this passage from Adomnán was in the mind of the writer, there may be a comment in this page on the difficulties of living in community, both for those suited to the life and to those who were involved for other reasons. A large early Christian monastery in Ireland might house farmers, craftspeople and their families, together with pilgrims and penitents, all living within the sacred borders, under the authority and protection of the monastery and its founding saint. Life at close quarters with people of different personalities and habits, not all of them likeable, must have had its tensions. There is also a sense of commitment in the illumination. Every figure is touching at least one other person. Even in these moments, there is unity.

Some of the ancient poetry of the time rejoices in writing, scholarship and the pleasures of the natural world. There are also allusions to drunkenness, a condition for which there were only limited opportunities in a life dominated by long regular periods of prayer, limited sleep and fasting twice a week as well as in seasons such as Lent. Bouts of drinking were more associated then with the secular dwellings of kings than with the monastery, but perhaps from time to time they occurred, and their consequences jarred with the order desired from this way of life.

There are the days when it may have all been too much, as it seems to have been for the figures in this illumination. A poem attributed to Columcille, though written in the eleventh or twelfth century, is translated, with its metaphors of drunkenness and the fairground, along with copying from books, which contain more knowledge than humans can ever manage to absorb:

> My fist is weary from writing
> My keen-edged pen is raggedy
> My beaky narrow pen spews
> A beetle-coloured drink of clear blue-black.

A stream of strong wisdom gushes
Out of my good brown shapely right hand
It pours its drink over the page
In ink of the green-skinned holly tree.

My little dripping pen goes
Across the fairground of beautiful books
Without ever coming to the end of the goods of experts
And thus my fist is weary from writing.[3]

The illumination perhaps reflects mornings like this, when the night before was felt, and members of the community were overwhelmed by the enormity of the task of copying and sometimes illuminating works of knowledge, especially the scriptures. The use of poisonous inks, the regular fasts and long hours of prayer may have made the breaks seem good at the time, even if they paid for them later.

It was not like this all the time. Above the twenty figures in the text are other figures. Two at the top are lying, apparently decently asleep. Below them are four figures, following the monastic life. They are beard pulling, drawing each other to hear the Word of God and to listen to it from each other. They are doing it at dawn, half-dressed. Beneath them are three fainter, incompletely coloured figures, fully dressed, two of which at least are engaged in beard-pulling. Ignored by the party-goers below, they seem to be involved in the normal daily routine. Perhaps this is the point: there are times for sleeping, waking and the daily round, all of them involving prayer.

Yet, even with all these figures and the strange beast with its body hidden, this is mainly an abstract page, full of curves and spirals. The long right-hand panel that protects the edge of the book and wards off evil is filled with snakes and vines. Elsewhere, circular forms predominate. Whatever the purpose of this page, there is a deliberate discordance between the design and the activities of the figures. However, the palette of colours used is the same, comprising mainly deep, rich blues, golden yellow and shades of red. The illumination presents a unity.

The poems and prose that have come down from these centuries suggest that many people found the solitude, orderliness and stimulation

they craved in the monastic life. Starting and ending the day had their own rounds of prayers.

—❦—❦—

May thy holy angels, O Christ, son of the living God, tend our sleep, our rest, our bright bed.

Let them reveal true visions to us in our sleep, O High-prince of the universe, O great mysterious King.

May no demons, no ill, no injury or terrifying dreams disturb our rest, our prompt and swift repose.

May our waking, our work and our activity be holy; our sleep, our rest, unhindered and untroubled.[4]

NOTES

1. Flower (tr.), printed Murray, *The Deer's Cry*, p. 33.
2. O'Loughlin (tr.), Adomnán's *Holy Places*, pp. 61–3.
3. Cathy Swift (tr.). Used with permission. There are historic translations by Kuno Meyer, while there is another translation in Murphy (ed. and tr.), *Early Irish Lyrics*, p. 71.
4. Tenth century, Irish. Murphy (ed. and tr.), *Early Irish Lyrics*, pp. 44–7.

PORTRAITS

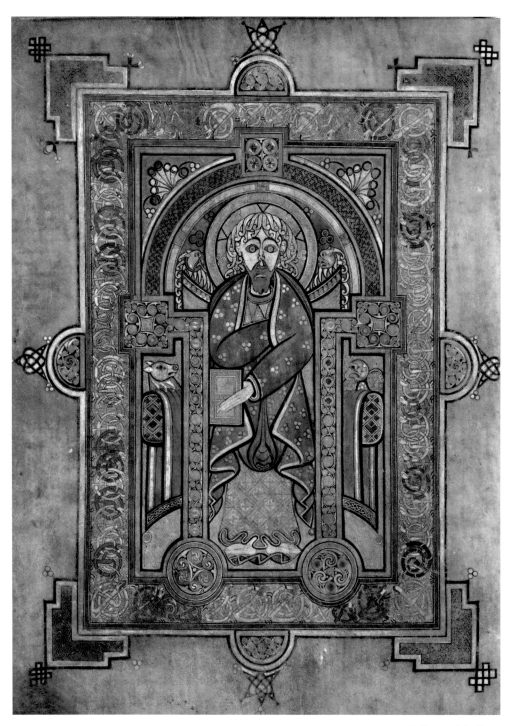

Folio 28v: Matthew

✢ 9 ✢
Matthew

Who is God
And where is God
Of whom is God, and where his dwelling?
Has he sons and daughters
gold and silver, this God of yours?[1]

N THE BOOK OF KELLS ONLY TWO EVANGELISTS' PORTRAITS
have survived: those of Matthew and of John. This portrait at
the start of the first gospel sets the scene.

The unity of the gospels is, as we have seen, constantly
emphasised in the Book of Kells and other ancient gospel
books. For Matthew's gospel we have the single page with
the four evangelists, then this portrait, which faces the great
initial page for the beginning of his gospel. The portrait of Matthew
displays a stylised human figure surrounded with intricate detail, within
a patterned border. The colours are now, and probably always were,
subdued, with pinkish hues predominating. They relate not to the
brilliant colours of the opening words of Matthew's gospel, but more to
the stronger pink hues found a few leaves on, in the Chi Rho page of the
'second opening', and to the carpet page which may have been placed
opposite it. The geometric halo is similar to the designs on these pages.

Matthew stands facing the onlooker, barefoot, with curling golden
hair and a darker beard, like Jesus in the portrait that follows a few pages
later, and has been bound there to relate to the 'second opening', the birth
of Christ. Behind Matthew is a chair, the place of teaching authority, the
arms draped, a feature later seen on John the Evangelist's chair. Matthew
stands, wearing flowing robes that are patterned with the sets of three
small dots close together that we also see elsewhere on the robes of Jesus
and Mary. His right hand is hidden at his breast within his garments;
while the left hand, finely manicured and with long, straight fingers,
holds the book, his gospel, the source of his teaching.

Though preceded by the full page with the symbols of the four evangelists, this portrait of Matthew also contains representations of the other three. In panels on either side of Matthew are the stylised forms of Luke's ox and John's eagle. The image for Mark appears in two lions' heads on the back of Matthew's chair, at the level of his head.

Matthew's gospel is Jewish in focus but from the start emphasises the place of the Gentiles in salvation, and it was believed to be the first written down. Tradition had it that Matthew the Evangelist was Matthew the reformed tax collector, one of the twelve apostles, a model for all sinners seeking grace, and that he was executed by beheading.[2]

> As Jesus went on from there, he saw a man named Matthew sitting at the tax collector's booth. 'Follow me,' he told him, and Matthew got up and followed him. While Jesus was having dinner at Matthew's house, many tax collectors and sinners came and ate with him and his disciples. When the Pharisees saw this, they asked his disciples, 'Why does your teacher eat with tax collectors and "sinners"?' On hearing this, Jesus said, 'It is not the healthy who need a doctor, but the sick. But go and learn what this means: "I desire mercy, not sacrifice." For I have not come to call the righteous, but sinners.'
>
> MATTHEW 9:9-13

The portrait is the main feature of the page. Yet, as well as this stylised human figure, there are the usual intricate designs of beasts and abstract patterns, some of them hardly discernible to the naked eye. The arch is decorated, and so is each of the triangular sections between the arch and the rectangular border. Borders all have multiple edges, inside and out. Starting from the outer edges, there is a line of black, then gold, another fine line of black, gold again, blue edged with black, and then the main panel of decoration. Similar multiple lines are found on the inside edges, the multiple borders giving a sense of depth.

This pattern presents a combination of formal design, straight edges combined with the seemingly spontaneous but planned images within borders. It was undertaken in eye-aching detail and with a steady hand. The interlace of birds and snakes within the border similarly required

close attention. Each is in a spiral, coiling inwards, the colour and tension contrasting to the stillness of the central figure. The inner rectangular panels also have their minute circular designs in geometric patterns. They even repeat on the cover of the book Matthew holds.

Returning to the border, some of the circular creatures have claws and wings. It seems that here as in other places intertwined figures with elongated, curving bodies were intended to combine the features of bird and snake. In early Irish literature birds sing the canonical hours, as on the islands where St Brendan and his followers met communities of hermits. A bird silently lit the candles for the evening chanting of hours. Three birds sang the canonical hours before the Creator in the Vision of Adomnán, attributed to the ninth abbot of Iona, though it was actually written later.[3]

In the Book of Kells, the first gospel seems to have been decorated in the richest detail and there seems to be the greatest number of links to other illuminations. Matthew's version of the Passion seems to have been the most used in the liturgy. The care and attention may have been because this gospel was prepared in the first rush of enthusiasm, or it may have been that there was special reverence for this evangelist. A now incomplete cross was raised on Iona some two centuries later, and is traditionally named after St Matthew, and stood close to those known as St Martin's and St John's crosses. On the east face of the shaft is carved the temptation in Eden, which would have caught the dawn light. Was this image seen to relate particularly to the Gospel of Matthew, the Jewish Gospel that relates back to the Jewish story of Genesis, which speaks of all humans as descendants of the first parents, just as salvation through the descendant of Adam and Eve is the source of salvation for all peoples, as the final verses of Matthew's gospel declare?

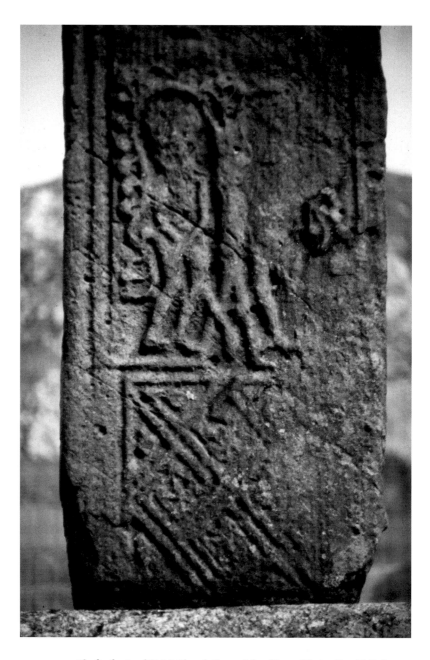

Shaft of ruined St Matthew's Cross, Isle of Iona. *Photo: David Coleman*

Returning to the Book of Kells, there are matters that seem strange or incomplete in the portrait. The pink colour extends even to Matthew's eyes; his left eye is also incompletely drawn, leaving him partially blind. On the opposite, opening, page of his gospel, one of the angels has no facial features. The page of evangelists' symbols prior to Mark's gospel similarly shows the symbol of Matthew as a blind figure. It may be that the Scribe-Artist returned to the work after a hiatus, without his companion and much weakened in his powers, unable to complete everything. But these may be deliberate omissions, an indication that no work of art can ever be perfect, that perfection is the prerogative of God alone.

Decoration of this, the first gospel, was not complete. It seems that parts of the scriptures used on high days were given precedence when it came to illumination. Matthew's gospel starts with the genealogy and conception of Jesus, told from the perspective of Joseph. The beginning of the calendar year was the time of the feasts of the Circumcision of Jesus, and of the Epiphany, the showing of the child Jesus to the Gentiles. The genealogies, the human ancestry of the Christ, were read in the liturgy, as part of the divine plan, and a plan they could understand from within their own culture. The text is written in a clear hand but the decoration consists only of the outline for a border and cross similar to that which holds the symbols of the four evangelists that precede the gospel, with yellow added at some of the capitals and corners.

The other genealogy of Jesus, in Luke's gospel, is highly embellished, as in other books, like MacRegol and the older Lindisfarne Gospels. This starts with Jesus as the supposed son of Joseph and works backwards through the great figures of the past including David, Isaac and Jacob to Adam, the Son of God. Irish genealogies similarly worked backward through the male line to a common ancestor, taking in ancient heroes. A genealogy of Jesus was significant in showing God made human, born into a certain tribe, time and place, with all the obligations, rights and duties of kinship. It made explicit that Jesus had relatives, and knew his ancestors and their deeds. When the monastic community read in the scriptures how Jesus made connections with the actions of Old Testament figures, he was doing the same as what the leaders of their own day did when they told stories about ancestral heroes, connecting their lives to figures of the past, using them as models for people of their own time.

Image & Vision

The monastic community comprised people who had to some extent abandoned the lifestyle where genealogy and kinship ties mattered most, a society of kings and local loyalties, of violence and at best temporary successes, but they knew its significance and traced their own spiritual family in a similar way to their founding saint.

The readings came in the cold months, around the period of Epiphany, when work was limited by natural daylight. For some, the monastic round provided its own solace. Matthew's gospel was part of the round of liturgy that ordered the day.

This is a highly ordered portrait of the Evangelist, but its position close to the portrait of Christ suggests that the onlooker is to see him as a pale image of the Godhead. This is a delightful and detailed work of art in gentle colours, a pointer to the Christ met in the scriptures. It also helps us to wonder how the artist may have portrayed Mark and Luke, whose images were never completed or have been long since lost.

A hymn from the ninth or tenth century was translated in 1905 by one of Ireland's early female scholars, Mary Byrne (1880–1931). The translation is better known as the hymn by her contemporary, Eleanor Hull (1860–1935).

Be thou my vision, O Lord of my heart
None other is aught but the King of the seven heavens.
Be thou my meditation by day and night.
May it be thou that I behold even in my sleep.

Be thou my speech, be thou my understanding.
Be thou with me, be I with thee
Be thou my father, be I thy son.
Mayst thou be mine, may I be thine.

Be thou my battle-shield, be thou my sword.
Be thou my dignity, be thou my delight.
Be thou my shelter, be thou my stronghold.
Mayst thou raise me up to the company of the angels.

Be thou every good to my body and soul. *Matthew*
Be thou my kingdom in heaven and on earth.
Be thou solely chief love of my heart.
Let there be none other, O high King of Heaven.

Till I am able to pass into thy hands,
My treasure, my beloved through the greatness of thy love.
Be thou alone my noble and wondrous estate.
I seek not men nor lifeless wealth.

Be thou the constant guardian of every possession and every
life.
For our corrupt desires are dead at the mere sight of thee.
Thy love in my soul and in my heart –
Grant this to me, O King of the seven heavens.

O King of the seven heavens grant me this –
Thy love to be in my heart and in my soul.
With the King of all, with him after victory won by piety,
May I be in the kingdom of heaven O brightness of the son.

Beloved Father, hear, hear my lamentations.
Timely is the cry of woe of this miserable wretch.
O heart of my heart, whatever befall me,
O ruler of all, be thou my vision.

NOTES

1. Early Irish, in Latin, as questions put by Eithne Alba to St Patrick. Carney (tr.),
 Medieval Irish Lyrics, pp. 2–5; also Murray, *The Deer's Cry*, pp. 17–18.

2. His death is mentioned by Blathmac, *The Poems of Blathmac*, Carney (ed.), 248, pp.
 84–5.

3. Carey, *King of Mysteries*, p. 266.

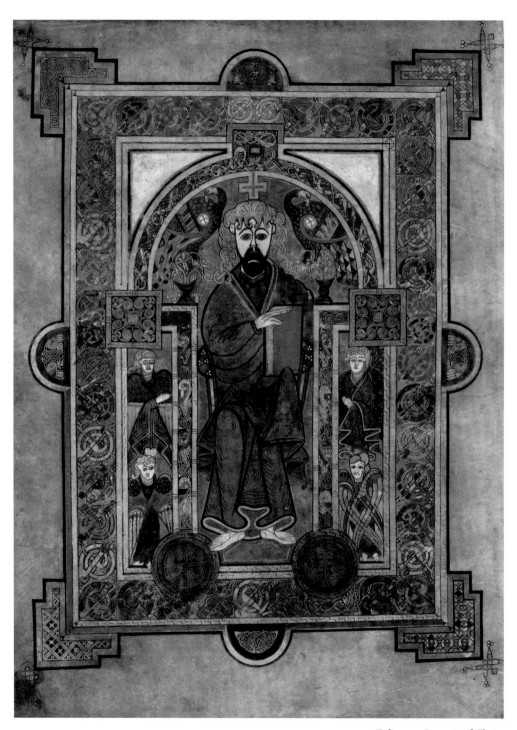

Folio 32v: Portrait of Christ

✝ 10 ✝
Christ Portrayed

It were my soul's desire
To see the face of God;
It were my soul's desire
To rest in His abode.[1]

HIS FULL-PAGE PORTRAIT OF CHRIST IN BRILLIANT colours shows a youthful figure with a whitened face, reddish-golden, curling hair flowing down his shoulders, and a darker beard. Like the sixth-century icon of St Catherine's monastery known as *Christ of Sinai*, and many icons since, he faces the onlooker directly. He also, as we will see, appears to move out of the portrait towards the onlooker.

He appears at first sight to be standing, but a closer look reveals that he is seated, in a chair far less elaborate than those of the evangelists Matthew and John, one knee visibly raised. With his left hand, hidden by the triangular fold of his cloak, signalling the holiness of what is touched, he holds a book, red-bound. His right hand also holds it and has two fingers raised in the traditional blessing, the fingers indicating Christ's two natures in one, divine and human. He has no halo but around his head are the signs of the Passion and resurrection.

It is on a single sheet of vellum, used only on one side, and has been bound just before the second opening of Matthew, 'Christ was born in Bethlehem of Judea', and opposite the carpet page, a page of abstract decoration in the form of a cross. It cannot be certain that this was the original position, but it seems that it was intended to appear at the start of the gospels. The style has the same overall design as the portrait of Matthew, but a different palette of colour.

Shortly before the symbols of the evangelists, Matthew's own portrait and the full-page text illumination have marked the beginning of his gospel. Before them appears the Virgin and Child portrait, among the preliminary matter to the gospels. Ahead of these came the canon tables, with their rich visual opening to the book.

This portrait of Christ echoes Matthew's closely in design and style but is much more vivid in colour, so that Matthew's portrait in rose colours a few pages earlier foreshadows that of Christ. Christ at the Incarnation is coming to the community of believers and to the individual through the scriptures, the written Word. Matthew and his successors as scribes are servants of the Word. Christ in bright colours is the light of the world:

> The true light that gives light to every man was coming into the world. He was in the world, and though the world was made through him, the world did not recognise him. He came to that which was his own, but his own did not receive him. ... The Word became flesh and made his dwelling among us. We have seen his glory, the glory of the One and Only, who came from the Father, full of grace and truth.
>
> JOHN 1:9-11, 14

He is also coming like the dawn from on high, bringing light to those who sit in darkness, in the image of the Song of Zechariah, the Benedictus (Lk 1:78-9).

As in Matthew's portrait, the figure appears within a border, with an arched roof, and while there is no relief or perspective, the artist has given the impression of movement as well as stillness.

This is one of several portraits in the Book of Kells where Christ is depicted without a halo. He has none in his portrayal as a child with his mother, though she has one; none on the Incarnation page already considered and which follows shortly in this gospel; nor on the Arrest page; nor on the Crucifixion page of Mark's gospel. Instead, Jesus is surrounded by indications of his work on earth.

Above his head, joining him to the arch is a cross. On each side are two peacocks, each curved to fit within, and touch, the arch of the world. The resurrected Christ is already present in this portrait, which appears at the start of the gospel's story of Incarnation. Further, this portrait of Christ in glory follows just after the text of the genealogy of Jesus, which roots him in human life at a time and place, and is followed by the story of how he was conceived. Both cross and resurrection, having been established outside of time and place in the eternal Godhead, and prophesied in the scriptures, are present here.

On the breasts of the peacocks are circular, white Eucharistic breads
with a cross on them. Beneath the bodies of the peacocks and sheltered by their feathers are chalices from which grapes pour, and the feet of the peacocks rest on the vines. As yet the chalice is not full and the wine not ready to be drunk. It is implicit that the grapes are an indication of the new wine of Paradise of which Jesus speaks at the Last Supper (Mt 26:29, Mk 14:25, also Lk 22:18). As the vines touch the hair of Jesus they also indicate his saying: 'I am the vine, you are the branches' (Jn 15:5).

The feeding of God's people with the bread and wine, the cross, the cost and the consequences of eternal life with Christ are all implicit.

Christ is robed in the traditional colours of red and blue. His garments have clear, contrasting borders. His upper garment has three folds in it, and these are repeated on the sleeve. The triangular shape of the mantle covering Christ's left hand also indicates the Trinity, and above his knee the mantle lies in stiff, triangular folds. The chair behind him has drapery that is patterned with clusters of three small dots, similar to those found in the previous portraits of Matthew and of the Virgin and Child. Like Matthew, Jesus wears a long robe, and this also is decorated with clusters of three dots. The hand raised in blessing seems to contain near his wrist a red ring with a smaller ring within it, perhaps the sign of a nail that pierced him.

There is no translucent wash to give depth to the picture, and yet there are indications of movement. The peacocks have different coloured legs, as if hovering. While Matthew is static in his portrait, Christ, though seated, is coming forward. The toes of one foot have moved beyond the decorated circles, outwards towards the onlooker on whom Christ gazes. He is teaching, blessing, giving the Word, and also coming to meet his people. Christ emerges from within the text of scripture, walking towards the onlooker, and the community. From the time of the Incarnation of Christ, as proclaimed through the neighbouring texts, this has been planned for: Christ on the morning of the resurrection coming out of the Word to complete it; coming to meet his followers as he met the women at the tomb (Mt 28:9). He is also walking out of the more local 'place of resurrection' to meet the onlooker, on Iona where Columcille died, or at Kells where his relics were preserved.

The overall design of the page echoes the design in Matthew's, but with differences. There are again two rectangular inner panels. In Matthew's

portrait these contain symbols of two other evangelists but here they contain four beardless, winged figures. These can refer to the evangelists, here winged as bringers of good news. They also link the viewer to other illuminations where Christ is accompanied by four angels, as in the Virgin and Child portrait, the Temptations page and the morning of the resurrection in Luke's gospel. Here, one of them holds a staff – a symbol of office – while opposite another appears to be indicating the portrait of Christ. All look outwards, not directly at the onlooker, but, like Mary, gaze beyond the picture's border, drawing the onlooker in to contemplate the main figure. The corresponding internal panels contain abstract design in Matthew's portrait, but here they are filled with interlocking peacocks. The panels end with square designs filled with spirals near the level of Christ's shoulders, and below in circular panels that contain minute labyrinthine designs in the form of crosses. If they were intended to give the impression of pillars of the building, perhaps the model was again the circular church above the 'place of resurrection' in Jerusalem and their local equivalent, the circular Irish monasteries within which lay sacred space.

These panels end in square panels, which hold up the arch, and are also filled with interlocking elongated creatures. The apex forms a rectangle above the cross and Christ's head, and within this in the centre is a smaller black rectangle. It may be that this is a reliquary, a reference to the Passion, but one that is empty because Christ is risen. It would bring to mind reliquaries known to the original audience, believed to contain relics of saints who shared the Passion with Christ while on earth.

The main border is, as in Matthew's portrait, filled with larger, intricate, interlocking creatures that form a continual pattern of spiral and cross, picked out by the colours at each corner. The pattern continues outside the border, with corner extensions, each of the same shape and colour as the border but with a separate yet harmonising abstract design. At the middle of each side of the rectangle is a semi-circular extension to the main border within which two more peacocks can be seen.

Within the arch, the background to Christ is simple, where in Matthew's portrait it is filled with further decoration. The triangular spaces between the arch and the upper border are filled with design in Matthew's portrait, but not so here, where they are a brilliant white. This was added in the nineteenth century, and underneath it a seventeenth-

century hand had written 'Jesus Christus'. The original artist more pleasingly left these spaces as blank vellum, providing space within the protective border. (See the front cover for this effect.)

There is a unity in the ways in which Christ's figure touches the other elements. Christ's chair touches both side panels and his feet touch the circular panels at their base. His left side touches the chalice, grapes and smaller side-panel. This portrait serves to connect, in artistic ways and through placing. It is foreshadowed, as we have seen, in Matthew's portrait, and also has the vivid colour scheme of John's later portrait, which will be considered next.

The Christ portrait has been bound for centuries opposite the carpet page – the Alpha and Omega opposite the intricate design with no beginning and no end. Perhaps this page, or the two pages together, were used on certain festivals throughout the year. At these times, perhaps, the Book of Kells was taken out from its protecting shrine, out of the original small dark church where it was usually in safekeeping, into the open air, to be seen by a wider congregation of believers.

This portrait sits near the beginning of the book. Christ is attended by four angels and by symbols of Eucharist, Passion and resurrection. They are arranged around his head in place of a halo. Christ the same, yesterday, today and forever, with no beginning and no end, is presented to the onlooker. This is Christ the Protector, portrayed within one of the chief relics of the monastic family of Columcille, and a means to engage with the life of the spirit at deepening levels.

To continue the eleventh-century poem with which this section started, as translated by Eleanor Hull in the early years of the twentieth century:

It were my soul's desire
To study zealously;
This, too, my soul's desire
A clear rule set for me.

It were my soul's desire
A spirit free from gloom;
It were my soul's desire
New life beyond the Doom.

Image &
Vision

It were my soul's desire
To shun the chills of Hell;
Yet more my soul's desire
Within His house to dwell.

It were my soul's desire
To imitate my King,
It were my soul's desire
His ceaseless praise to sing.

It were my soul's desire
When heaven's gate is won
To find my soul's desire
Clear shining like the sun.

Grant, Lord, my soul's desire
Deep waves of cleansing sighs;
Grant, Lord, my soul's desire
From earthly cares to rise.

It were my soul's desire
What ever life afford –
To gain my soul's desire
And see thy face, O Lord.

NOTE

1. Hull, *The Poem-Book of the Gael*, pp. 142–3 and Murray, The Deer's Cry, pp. 44–5.

✛ II ✛
John the Evangelist

Pleasant to me is the glittering of the sun today
upon these margins, because it flickers so.[1]

OHN'S GOSPEL STARTS IN *PRINCIPIO ERAT VERBUM*,
'In the beginning was the Word'.

The Book of Kells is, as we have seen, a gospel book,
designed for liturgical use, one that emphasises that the
four gospels are unified, and that they are together the
Word made visible, incarnate, and transmitted on pages made from the
skin of animals, by human skills and labour.

The portrait of John faces the gospel's initial page, *In principio*; the
colours harmonising, blues and purples predominating, the corners picked
out in golden yellow. The decorated initial page opposite is as detailed
as its fellows. At the top, a human figure holds out a book. His robes are
arranged in a triangle pointing towards it, similar to the arrangement of
clothing in the portrait of Matthew. At the top right, a figure wrapped in
contemplation sips from a chalice, while a great beast with jaws open,
pointed teeth bared and tongue curling, confronts but cannot touch him.
Intricate circles within circles appear in the decoration of this initial page
and balance the great halo on the portrait of St John opposite.

John's gospel itself is slightly hurried. There are more lines of text
to the page, on average eighteen rather than the sixteen or seventeen
that are the norm. The text remains widely spaced and pleasant to read,
suggesting that the provision of calfskin was not the main consideration
for the change. There are many small drawings to accompany and to
mark the text for the readers, but there are no, or there are no longer,
any major illuminations to mark specific passages. The final half of John's
gospel is missing, perhaps never completed, perhaps ripped off when
the cover was stolen in 1007, perhaps lost in the years since. But there
is nothing hurried about the opening illuminations, the evangelistic
symbols, portrait and initial page, which match the other gospels.

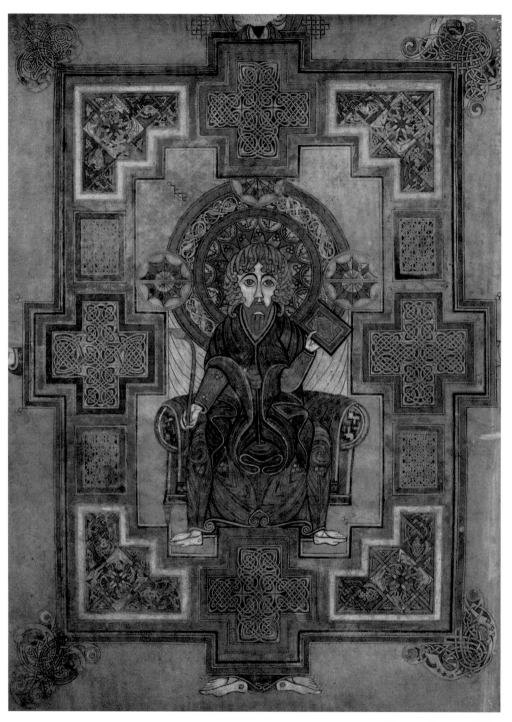

Folio 291v: Portrait of John

Traditionally, the writer of the fourth gospel was taken to be the 'Beloved Disciple' of the gospel, and considered to be the John who was the brother of James the fisherman. Saint John's gospel seems to have been particularly significant in the Irish tradition.

In this portrait, John is given honour in that he sits, in the posture of a teacher, rather than stands like Matthew. His chair is rounded, like that of Christ's, but is more elaborate and covered in a fine drapery of rich blue. His left is hand raised and holding out his gospel, a book with a patterned cover. His other hand is lowered, and holds a large quill pen, below which is a small inkpot. His clothing consists of a red chasuble-type garment, which has three folds on the shoulders, similar to the folds in the portrait of Christ, and is edged with golden yellow. John wears beneath it a rose shirt, the arms of which are patterned with groups of three small circles. His lower garment is skirted, a translucent greenish colour, beneath which are elaborate designs outlining his legs and giving a sense of flow. There are, as we have become accustomed to, clusters of three small circles on his clothing, in his case four clusters of these, so there is reference both to the Trinity and to the evangelists. His feet again are bare, as feet are in the Book of Kells, and they point outwards, touching the panels of the border. Behind his figure is a canopy of white that reaches up to his elaborate halo.

John faces the onlooker directly. If it were not for its place in the Book of Kells, this might be a portrait of Christ. The figure is young, with golden, curling hair and an auburn beard, similar to the Christ of the Arrest page. However, as if to mark the difference between Christ and the Beloved Disciple, he is given brown eyes instead of blue.

The halo contains two main circles of patterns, with an additional circle on each side, and the half of a further one above, which serves to link the halo to the surrounding panel. The inner circle has the effect of making it appear that red sparks come from the head of John, while the outer one has a twisting, entangled yet disciplined design. The halo, white canopy and John's lower garments all touch the surrounding panel, as do his feet, his book, the inkpot and the pen. Most of the touching is at the four crosses in the border, theologically and artistically uniting them.

The border is made up of panels, which extend in the middle of each side to form a cross that is outlined in blue and matches the fabric on

the chair. They are linked by rectangles of abstract pattern that have their own borders in the same purple as the halo; and by corner panels bordered with yellow. Each set of panels has its own series of matching designs, giving the overall effect of combining the linear and the curving. Outside the panelled border, the corners each have their own additions, the design on the margin side more slender than on the outer side. At the outer sides of the crosses to left and right, there are groups of three small circles.

Although the central portrait touches this surrounding panel, the internal space between has been left empty. There were some tentative attempts, seen at the top left and lower right, to add a square decoration, but the overall impression is that of space. While Matthew's portrait is full of detail, this one is like the portrait of Christ, with vellum left blank, giving the eye space for the complex design to be seen.

The original writers were deeply conscious of the power of the written word, of its relation to Christ as the Word, and its transmission as a sacramental act.

> In the beginning was the Word, and the Word was with God, and the Word was God. He was with God in the beginning. Through him all things were made; without him nothing was made that has been made. In him was life, and that life was the light of men. The light shines in the darkness, but the darkness has not understood it.
>
> JOHN 1:1-5

The top right-hand corner was repaired at some stage in its history, but the page suffered its worst damage by cropping in the nineteenth century. At the lower edge, below the blue-edged crosses in the border, two feet appear, pointing outward, echoing the outward-pointing feet of the seated John above. A translucent red robe with a white hem hangs down to them. The ankles are marked with prominent circles, more prominent than on John's feet.

In the inner margin, again marked by the blue-edged cross in the panel, there is a hand, thumb outward, fingers turned inward, the wrist covered in a red robe with a similar white hem. This right hand is holding

something that has been almost worn away. It was thought to be a nail, but is now thought to be a flowering rod, the token of Aaron, the priest, brother of Moses. On the other side, also aligned with the cross in the panel, is another hand, retained when the rest of this margin was cropped, again with thumb outward, fingers inward, and the hem on the robe visible. At the top, above the final cross in the surrounding panel, a neck is just visible rising from the robe, together with golden curling hair and a halo.

The figure hidden behind the portrait of John, and behind the empty space and the adorned panel, is in the pose found on Irish high crosses, of the crucified but clothed Christ, resurrected, arms outstretched at right angles to his body, embracing the onlooker, protecting the sacred space of the monastery and those who seek shelter there.

The figure is drawn to the same scale as the evangelist. The feet and arms are outside the final blue edging to the surrounding decorative panel. The head of Christ, however, appears on the nearer side of this blue line, which runs behind him. Inner panels of gold, black and red obscure him, but he reaches out, as if from the middle of the design. Christ is invisible but present, and, as with the gospel appearances of the Resurrected Christ, these meetings are outside the onlooker's control. 'No one has ever seen God, but God the One and Only, who is at the Father's side, has made him known' (Jn 1:18).

There are similarities to the figure in the Crucifixion page of Mark, where the body is invisible even where the vellum is blank. Christ appears without his body in the portrait of this evangelist, the Beloved Disciple who leant on the breast of Jesus at the Last Supper, and was the only male disciple to stand at the foot of the cross. He had seen Christ, in Eucharist and death, and was a witness to the resurrection. In this illumination John the witness is transmitting to the onlooker the cross transformed by the resurrection.

It has been suggested that John's huge halo is again based on the plan of the circular church of the resurrection described by Arculf on his visit to Iona. If that is indeed the case, the church central to the resurrection is superimposed upon the cross. The two are visually united by the figure of John, witness to both, recipient of the salvation and everlasting life brought through the cross. He is also, as the writer of the fourth gospel,

the medium by which the Good News is brought to others, and the gospel closest to the tradition of Wisdom writings.

If this is a crucifixion scene as well as a portrait, the large pen John holds, out of all proportion to its inkpot, may not only represent his writing of the scriptures but may also hint at the lance that pierced the side of Jesus, from which blood and water ran (Jn 19:34); or the stalk of the hyssop plant which was dipped in sour wine which Jesus was offered to drink (Jn 19:29).

The cross, like the designs that have no beginning or end, serves to protect from evil, and perhaps here, where the tools of the scribe are present, there was the additional sense of protection for the original scribes and artists of this work. The embellished cross, an early theme of meditation across Europe, appears throughout the Book of Kells. In Old English there is a powerful expression of the bejewelled cross theme in the poem 'The Dream of the Rood', where the cross itself recites the story of the crucifixion. Part of this poem was inscribed in runes on the Ruthwell Cross, an Anglian freestanding cross in what is now south-west Scotland.

Saint John may have been especially revered on Iona. The oldest of the island's high crosses is associated with his name, and stood when first erected outside the shrine chapel of Columcille. This cross is huge, though slender, with a wingspan of more than two metres, and could not support its weight in a storm, so fell soon after it was erected. Masons added a ring-head to strengthen it, but it fell again. The cross was erected before the Vikings pillaged and enslaved, and was present if not always standing through the centuries of revival, decay and renewal that have been part of the history of the island. A replica now stands on its site, while the broken original has been raised again under cover.

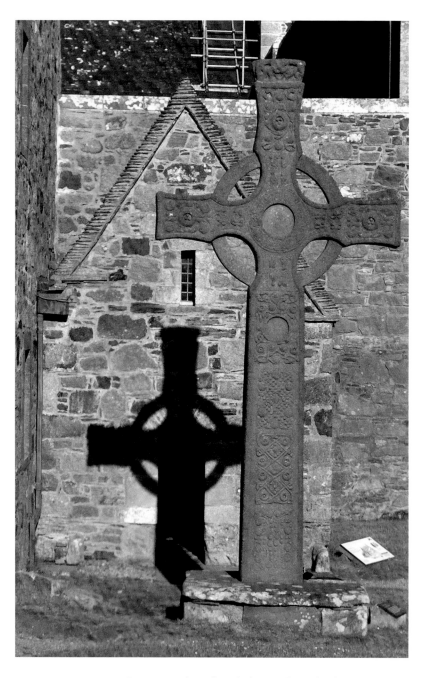

*John the
Evangelist*

Concrete replica of St John's Cross by Columba's shrine, Iona

Photo: Rosemary Power

With this cross and the portrait of John in the Book of Kells, we gain some insight into the faith of the community that produced them. Christ upholds the writer of this most mystical of the gospels, as John the teacher presents the Word to the onlooker. The image portrays not only John but the invisible Christ, the firstborn from the dead, the Word who became flesh, crucified and risen, who upholds John in his writing of the Word, and by implication all those who copy the Word. The scribes of the time, their successors in the monastic life, and all who see this work are part of this relationship.

Although the face of Christ is now lost, cropped in the nineteenth century when the book was rebound, like all marred icons it can sometimes provide new insights. This is the hidden but resurrected Christ.

> He is the image of the invisible God, the firstborn over all creation. For by him all things were created: things in heaven and on earth, visible and invisible, whether thrones or powers or rulers or authorities; all things were created by him and for him. He is before all things, and in him all things hold together.
>
> COLOSSIANS 1:15-17

The following poem, *Adiutor Laborantium*, 'Help of the Workers', is thought to be attributable to Columcille, and as such would be an early product of the Iona scriptorium, where copies of the scriptures and other texts were written, work for which Columcille's monasteries became famous. This poem was thought to be lost, but was identified in recent years from a damaged eleventh-century manuscript in England. The original begins each line with a new letter of the alphabet.

O helper of workers,
ruler of all the good,
guard on the ramparts
and defender of the faithful,
who lift up the lowly
and crush the proud,
ruler of the faithful,
enemy of the impenitent,
judge of all judges,
who punish those who err,
pure life of the living,
light and Father of lights
shining with great light,
denying to none of the hopeful
your strength and help,
I beg that me, a little man
trembling and most wretched,
rowing through the infinite storm
of this age,
Christ may draw after Him to the lofty
most beautiful haven of life
…an unending
holy hymn forever.
From the envy of enemies you lead me
into the joy of paradise.

Through you, Christ Jesus,
who live and reign ...[2]

John the
Evangelist

NOTES

1. Ninth century, marginal note in Irish by unknown scribe. Jackson (tr.),
 Celtic Miscellany, p. 177.
2. Latin. Clancy and Márkus, *Iona*, pp. 72–3.

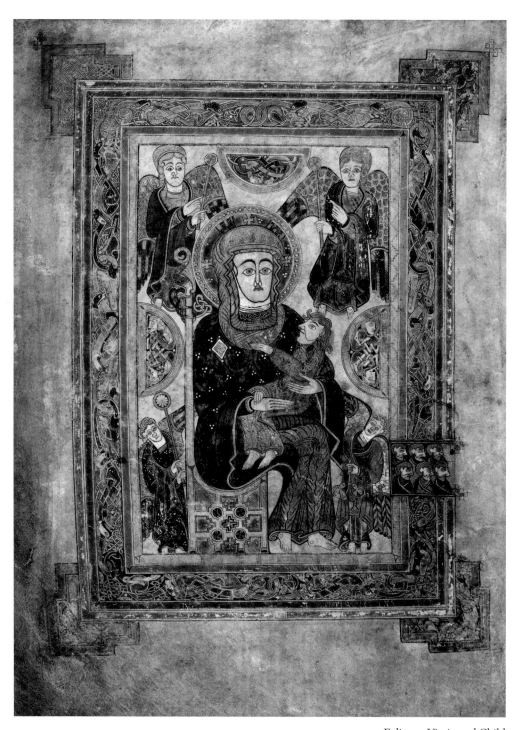

Folio 7v: Virgin and Child

✥ 12 ✥
Place and Protection:
Mary and her Son

Cantemus in omni die: Let us sing every day

> *Mary of the Tribe of Judah,*
> *Mother of the Most High Lord,*
> *gave fitting care*
> *to languishing mankind.*

> *Gabriel first brought the Word*
> *from the Father's bosom*
> *which was conceived and received*
> *In the Mother's womb ...*[1]

HERE IS A DOUBLE SPREAD NEAR THE START OF THE Book of Kells, among the preliminary material. On the left, verso, page is this image of Mary holding Jesus.

Mary is a statuesque figure, dressed as a woman of honour and wealth, a concept far from peasant Nazareth and the life of the young wife of a tradesman. Her headdress is that of a Roman matron, though her yellow hair curls out of it. She wears red and rose, or purple, garments and her robe is covered like that of Jesus and the evangelists with groups of three small circles, here coloured white. Her partly transparent halo, through which the wings of the sheltering angels are visible, also contains groups of three white dots, and three gold crosses hold the elaborate edges to her headdress. A diamond-shaped brooch gleams on her breast. She is enthroned on a chair with a jewelled base that contains the form of a cross, reminiscent of a ring-headed cross as a metalworker might design it. The chair ends in a lion's head, here a reference to Christ.

Mary is surrounded by four angels. Those at the top indicate and shelter her, while those below peep round her throne like children. The

upper ones again remind us of the angels above the head of Jesus in the Temptation page, and the ones on the edge of the 'Chi' of the 'Christ was born' page. These angels with outstretched wings hovered over the Ark of the Covenant and in the Holy of Holies of the Temple, above the Throne of Mercy, the place of God. They are carrying *flabella*, symbols of office, and are dressed like other angels and clergy in the Book of Kells, in cloaks and translucent robes. Mary is similarly clothed, in a translucent cloak of deep red and a flowing robe of rose or purple, beneath which her legs are clearly outlined. The clothing may represent silk, imported from the east through Byzantium, coloured in the most valuable purple dye, reserved for people of high status.

Mary is also a nursing mother, whose pendulous breasts and nipples show through her clothing, an indication of the intimacy of the Incarnation, of Christ becoming human and being born a child, with a child's needs. She looks outward, contemplating, while her child looks towards her.

Jesus has a smaller body than her but it is that of a grown man. As in many eastern icons, this is the Lord of Creation as well as a nursing child in his mother's lap. He is clothed in green and gold, the gold embellished with groups of three red dots, similar to the dots on Mary's clothing. There is no halo over his curling red-gold hair, and his face is beardless but still has a line indicating a beard. His features are those of a grown man, but he reaches across Mary's breast to hold her, while his other hand holds hers, and he looks into her face. He is here a child, sheltered by Mary, yet he is also the focus, his relationship with Mary and his union with his creation central to the illumination. This is not only the child on his mother's lap, but the God who became incarnate.

Mary seems to sit in silence, static where Jesus is active. Again as in eastern icons, she indicates Jesus to the onlooker. Her eyes are large and almond-shaped, and she looks outwards and beyond, inviting the viewer to contemplate with her. Her figure has other features we associate with icons. She sits, a sign of honour, yet also a practical way to hold a large infant. Mary wears the clothes of a high-born lady, but they are similar to the liturgical dress of other figures, like those of a priest. Her head is covered, as she is a married woman, but a viewer today may see her as ready to preach and proselytise, for a covered head is one of the requirements for a woman who preaches in Paul's First Letter to the

Corinthians (11:5), a passage which comes just before his account of the traditions he received of the Last Supper.

There are half-circle panels on each side of the main figures within each of which are two small figures with legs intertwined, as if dancing. A further panel above Mary's head contains two creatures similarly entangled, with bird-like heads and elongated bodies. Surrounding the figures, and in the same colours, is a complex border, the inner edge a broad band of golden yellow, followed by a pattern of interwoven birds within borders of purple. The design then has a further panel of red, now much faded, and there are outlying abstract designs edged with green at the four corners.

The border shows the usual close attention to detail, careful planning of the birds that flock and interweave. They may be representatives of the heavens, showing the ability of all creation to sing the praise of the Incarnation, and enfolding the picture with promise of resurrection for all who come under the protection of Christ. They are on the outer edge of the portrait, while the semi-circles with their designs, which are in the other illuminations outside the main border, are here inside it. This change, which crowds this small picture, serves to contain the figures of humans, the part of creation for whom Christ's Incarnation is intended.

Mary is presenting her son. This scene is also found on some of the high crosses, sometimes as the biblical presentation of Jesus to the Magi, celebrated at Epiphany as the presentation to all humanity.

> When they saw the star, they were overjoyed. On coming to the house, they saw the child with his mother Mary, and they bowed down and worshipped him. Then they opened their treasures and presented him with gifts of gold, and of incense and of myrrh. And having been warned in a dream not to go back to Herod, they returned to their country by another route.
>
> MATTHEW 2:10-12

This illumination is on a single piece of vellum painted on one side only and it cannot be certain where it was first placed in the book. It has been in this position since at least the twelfth century when the other side was used for a monastic charter. It is near the beginning as a verso, left-hand

page, opposite the start of the *breves causae*, the summary that precedes Matthew's gospel. The two pages seem complementary, one emphasising Mary's role in the Incarnation, the other with its intense decoration summarising the story.

The inner margin of the image is broken by a box containing the busts of six small figures, looking away from Mary and Jesus. There are similar figures looking away from the crucifixion text in Matthew's gospel, towards the blank page reserved for a crucifixion scene. Here, they are placed opposite a particular line on a recto, right-hand page.

If we look at this text page (fol. 8r), a human head at the top pulls interlacing from its crown and sprouts it from the lips, thinking and speaking the words. The text is written in various styles, with decoration between the lines. Images are included: a man holds an open book; a peacock darts down above him; and there are a host of other embellishments.

The first line of this page is in a curving text and starts with the first down-stroke of a huge 'N' for *Nativitas*, 'the birth', which stretches down to end opposite the busts of the six figures in the portrait margin. The first line of the text is in a colourful curl, with letters formed by snakes, and then a black ink takes over for letters of even height. At the line below where the first downstroke of the 'N' ends in a series of swirls, opposite the six figures on Mary's page, the visual boundary is changed. The writing now becomes black and angular, the letters in different sizes, in sudden contrast to the rounded, many-coloured letters of the first line. This angular script with letters of uneven size is used in other places, most jarringly in Mark's gospel, in the illumination of the text of the third hour of Jesus on the cross. They suggest creation has gone wrong, the content of the Word distorted. Here, the line towards which the six figures in the margin of the portrait look, reads: 'The Magi offer their gifts and the children are slain.' At the end of this line, a small solitary figure is seated, facing away from the words, his back to this brutality.

So the figures in the portrait of Mary and her son are not turning away from Mary and her child, but are pointing us to the link, the line that recounts both the presentation of Jesus and the slaying of the children of Bethlehem. Mary looks out from the left-hand page and over this page, which contains the summary of the story, including both its joy and its horror.

When they had gone, an angel of the Lord appeared to Joseph in a dream. 'Get up,' he said, 'take the child and his mother and escape to Egypt. Stay there until I tell you, for Herod is going to search for the child to kill him.' So he got up, took the child and his mother during the night and left for Egypt, where he stayed until the death of Herod ... When Herod realised that he had been outwitted by the Magi, he was furious, and he gave orders to kill all the boys in Bethlehem and its vicinity who were two years old and under, in accordance with the time he had learned from the Magi.

<div align="right">MATTHEW 2:13-15, 16</div>

The men in the portrait of the Virgin and Child are looking through it, towards the consequences. The child Jesus is not separate, safe within an unbroken boundary, but is Christ human and vulnerable to the cost and consequences of Incarnation.

Adomnán, abbot of Iona one hundred years before this image was made, recounts in his *Life of St Columba* a story from the saint's childhood in which a young girl was killed as she clung to his clothes and to those of his teacher. This event so outraged the saint that he cursed the offender, who died instantly. Adomnán also wrote what became known as the *Law of the Innocents* and persuaded secular rulers of Ireland and Pictland to adopt it. This law sheltered churches, children, clergy and women from combat and the need for women to engage in battle.[2]

The association with innocence and death must have been poignant on Iona, which, at about the same time this image was made, suffered the unexpected breaking of all boundaries. Vikings, who spoke an unknown language and knew nothing about the sacred space and sanctuary, but who sought moveable wealth, foodstuffs and young men to sell as slaves, came suddenly from over the seas.

While all these undertones do not avoid the Incarnation's sadder aspects, this is an icon of delight and movement. The long downstroke of the initial 'N' that reaches to the line that tells of the Massacre of the Innocents ends in circles, within which are three tiny peacocks. The whole outer border that stretches from the mouth and hand at the top and round the right-hand side of the text, ends below with two crossed,

sprawled, legs. The word that is trumpeted also shelters and protects, and the only place where the border is broken is the part which, through curls and circles, is open still to the ultimate spiritual protection of the Christ presented by his mother.

This is a very early western portrait of the Virgin and Child, and is in a prominent position, near the start of the gospel book. It has been suggested that, while the monastery was dedicated principally to St Columcille, it may have had a secondary dedication to Mary.[3] In the later Middle Ages, the monastery was associated with Mary, perhaps because of ancient tradition, and because there were tangible symbols of earlier devotion to her. She appears on at least two of Iona's high crosses, both of which have designs similar to that of the portrait in the Book of Kells.

Saint Oran's Cross is the older one. On one side, just below where the arms join the central upright, between two sheltering angels, Mary holds her large-bodied child. They turn to each other in a gesture of tenderness that can still be made out. Jesus' feet are naked and kicking the air like those of an infant.

This cross may have stood at the point where a medieval road crossed the boundary into the main monastic sacred space. Close by, the Reilg Oran cemetery, which was used for secular burials, had a chapel built in the twelfth century. This cross fell, or was broken, at some stage and was placed inside the chapel; the side with this carving placed downwards, which may have prevented its destruction after the Reformation, and meant that the detail was not weathered away.

Virgin and Child, St Oran's Cross, Iona. Late eighth century. *Photo: David Coleman*

Another cross, made out of a single piece of stone, still stands on its original site, beside the central sacred space of the monastery. Saint Martin's Cross is carved on one side with snakes that intertwine and rise upwards. On the side that looks westward to the medieval road close by are biblical scenes and in the centre, surrounded by four angels, Mary holds out Jesus. He is at the centre of the cross, the Incarnation placed in context, presented to the people and protecting those drawn to him. We can no longer see if the child inclines to Mary, or looks outwards, blessing the onlooker. She looks outward, facing the onlooker, protector of the monastery and those who call on her son.

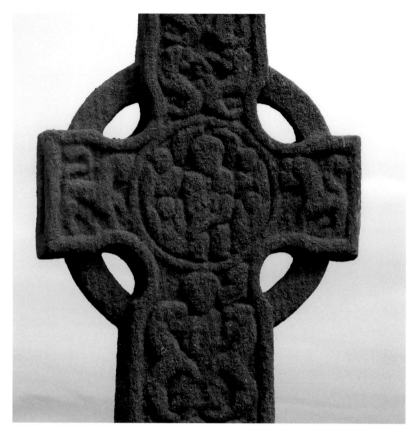

Virgin and Child, St Martin's Cross, Iona. *Photo: David Coleman*

Saint Martin's Cross has stood in the same place since it was raised. It was present as the monastery developed its scriptorium, and when the Vikings came. Later, the Benedictine church and cloister were erected nearby. It remained during centuries of neglect, corruption, rebuilding and the abbey's decay into ruin. Accounts by later visitors, like the Hebridean Martin Martin in 1698 and the Irish Bishop of Ossory, Richard Pococke in 1760, say that the islanders buried their unbaptised children here, where the imagery indicates the protection of Mother and Child.

A few other high crosses have the Virgin and Child depicted, such as at Kildalton on Islay, an island influenced by Iona. A smaller, broken cross on Iona also has two feet kicking, though the figures that would once have occupied its crosspiece have vanished. A century earlier in Anglo-Saxon Northumbria, a place where the Iona church had much influence,

St Cuthbert's coffin, designed for the translation of his relics, had a Virgin and Son incised on the lid; the son so large it appears like a pietà, Mary holding Jesus taken lifeless from the cross. There are later depictions too, for example at Inglesham.

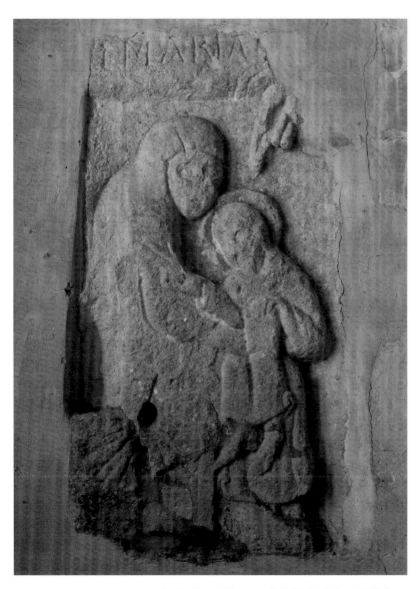

Anglo-Saxon Virgin and Child, Inglesham, Wiltshire.
Later used as a sundial. *Photo: ASP Religion / Alamy Stock Photo*

None of the carved depictions has the wealth of details that a manuscript can supply, nor can they resonate like a series of illuminations in a gospel book. The Book of Kells has given us the oldest manuscript depiction of Mary in western Christendom, and the high crosses of the Iona monastery come from the same understanding of the Incarnation. This image is a presentation scene, in which Jesus is offered to the onlooker. The illumination is akin to the scene in the centre of St Martin's Cross with its four attendant angels, but the way in which Jesus looks towards his mother, his naked feet dangling, connects it with the intimate relationship of Jesus with Mary of the St Oran Cross.

There are matters of symbolism in the Book of Kells image that are no longer understood. Jesus has two left feet and left hands while Mary has two right feet. Similarly, the angels on the left seem to have their limbs confused. The artists had skills to depict them correctly, and were concerned with detail that extended to the shape of the fingernails, so it would seem that these were intentional. The angels are dressed in liturgical garments, as they are elsewhere, but Mary is dressed similarly, placed centrally, as a celebrant would be. This may suggest, given the strong emphasis on the Eucharist in the Book of Kells, that this is the presentation of Jesus not only in general, but more specifically in the Eucharist.

The illumination has the movement of Jesus and the angels contrasting with Mary's contemplative stillness. There is also, when the two pages are taken together, the fear or remembrance of violence, the knowledge that the crucifixion is imminent, even at the start, for Christ and for his followers, for the figures in the margin look to the disjointed script used to recount the Slaughter of the Innocents. Mary holding the child Jesus looks over the text of slaughter, and another kind of protection is offered, whatever physical harm may come.

Cantemus in omni die: Let us sing every day. A monk of Iona composed this hymn, quoted at the start of this chapter, in Latin in about 700 CE, roughly one hundred years before the Book of Kells was made. It ends:

> Let us put on the armour of light,
> the breastplate and helmet,
> that we may be perfected by God,
> taken up by Mary.

> Truly, truly, we implore,
> by the merits of the Child-bearer,
> that the flame of the dread fire
> be not able to ensnare us.

> Let us call on the name of Christ,
> below the angel witnesses,
> that we may delight and be inscribed
> in letters in the heavens.

NOTES

1. Clancy and Márkus, Iona, pp. 182–5.

2. Adomnán, *Life of St Columba*, ii, 25, Sharpe (tr.), pp. 174–5.

3. Farr, *Book of Kells*, pp. 145, 154.

Part III

CONNECTION
AND COMPOSITION

This book has attempted to show something of how some of the illuminations in the Book of Kells can be a source of reflection today. We have considered the relationship each image has with the text, as well as how the illuminations work as a sequence, enhancing each other and giving new depths to the work of the artists. The separate parts are not just icons in their own right but enable the Book of Kells to add up to something larger still. It has not been possible to consider even half of the full-page illuminations and none of the minor ones, but the reader may find that study of them reveals similar, and unexpected, depths and inter-relationships. This work was not only a source of pride and an object to display and impress for the communities in which it was held, but remains a source of spiritual reflection.

Today we have the advantage of being able to read the gospels in a language of our choice, as well as to view this work directly or in reproduction. This has made the Book of Kells accessible in a way our ancestors could not have envisaged. As with any other great work, or collection of works of art, our modern interpretations also have their place, especially when informed by the past.

The intention of the original creators was to produce a work of spirituality, but they were products of their age as we are of ours, and there may be elements that will bewilder or jar the senses as well as those which delight or give pause for thought. A theology of beauty as a means to the divine, and a respect for the skills that enable art to be creative in a manner that touches others, is one of the means by which a work of this kind can be appreciated. A historical approach may involve an acceptance that some matters are beyond our reach but may be comprehensible to our descendants.

We now turn to considering the book as a whole, as an icon, a 'true image', which allows us a window into the contemplation of eternal matters and in particular the original artists' approach to the four gospels. This requires a brief consideration of the Book of Kells' history; the way of life for the community that produced it; the methods, materials and artistic influences that created it; and finally something of what it

means to people today. Much more can be found from the references in the bibliography to the scholarship that is helping to develop a fuller understanding of this unique ancient manuscript.

As we have seen, the Book of Kells is thought to have been produced in the years around 800 CE, in likelihood to honour Columcille's bicentenary in 797 CE. It is assumed that it was started on Iona, where the monastery was the place of his death and burial, which had a major scriptorium, a place of writing large enough to have produced this work. Françoise Henry, the scholar who laid the grounds for recent scholarship, suggested that it may have been started under the direction of the Iona scribe Connachtach, who died in 802. There may have been delays in preparing work of this quality, and other events, such as illness within the community or bad weather, which interrupted the supply of traded goods.

Vikings raided Lindisfarne in Northumbria, and Iona must have prepared to defend itself against similar attacks, for the *Annals of Ulster* record widespread devastation by Vikings for 794. Iona's turn came soon afterwards as we have seen, at the least disrupting the lives of those who made a book of this kind possible. Perhaps this too explains some of the unfinished parts. In 814 the church at Kells was completed, and the abbot and many of the community left Iona for this inland site, taking with them many of the prized possessions for safekeeping, including probably the unfinished book that became associated with what was now the leading monastery of the Columban *familia*.

We have considered something of how it was made, and can learn more from at least one sister-monastery. Recent excavations in north-east Scotland, at Portmahomack, show evidence of a large and thriving coastal monastery that produced both fine metalwork and vellum manuscripts on site, seeing the process of manuscript-making through from slaughtering the calves to the finished writing. The monastery suffered a devastating fire in about the year 800, after which manuscript production ceased. Some of the monastic skeletons show signs of extreme violence, and although some work on the site continued, it appears that a Viking raid destroyed the monastery.

In spite of similar dangers, a monastic community continued to live on Iona, even after another brutal raid in 825. Further raids occurred throughout the ninth century and other relics were taken from the island

for safekeeping elsewhere, including to Dunkeld in central Scotland. Even without precious goods to attract them, Viking interest in Iona continued: nearly two centuries after the first attack, on Christmas Eve in 986, the abbot and fifteen clergy were killed.

An anonymous poet in Ireland made a quatrain that captures some of the anxiety of the time:

> *Is acher in gaíth innocht*
> *fu-fuasna fairggae findfholt*
> *ni ágor réimm mora minn*
> *dond láechraid lainn ua Lothlind*

> *The wind is fierce to-night*
> *It tosses the sea's white hair*
> *I fear no wild Vikings*
> *Sailing the quiet seas.*[1]

Life on Iona became more stable as the years passed. The buildings were repaired in the late eleventh century by Queen Margaret of Scotland, while the 'little church of Columcille', probably the older shrine church where the rebuilt St Columba's chapel now stands, was visited by the Norwegian king Magnús Barelegs in 1098. A glimpse of Iona in 1164 from the *Annals of Ulster* shows that within the monastic enclosure there was a main community, a group of ascetics and also a hermit on the island. There may also have been a nearby women's religious house, providing hospitality for the women among the penitents and pilgrims who continued to visit. In the later twelfth century a nunnery was built on the island, the ruins of which remain, while in 1203 a Benedictine abbey was raised on the original site to supersede the Columban monastery.[2] This was expanded several times, but the buildings finally fell into disuse after the Reformation. In the late-nineteenth-century work began on restoring the abbey church, and the cloisters and living quarters were rebuilt by the Iona Community in the mid-twentieth century.

The monastery at Kells, with its high crosses, stone church and later a round tower, suffered its own privations. It was raided several times by Vikings, by local Irish rulers and by a mixture of both. There was also the

danger of opportunistic theft, such as that of 1007, recorded in the *Annals of Ulster*, when, according to the older translation, 'The Great Gospel of Colum Cille was wickedly stolen by night from the western sacristy in the great stone church of Cenannas [Kells]. It was the most precious object of the western world on account of the human ornamentation. This gospel was recovered after two months and twenty nights, its gold having been taken off it and with a sod over it.'[3] It seems from this account to have been normally kept in the stone church, and to have been encased in a shrine, which we can deduce from surviving book shrines was a work of art in its own right.

The shrine was lost but the book remained at Kells, and in the twelfth century, as was the custom at the time, blank pages were used to record charters. Further blank pages were used in the later Middle Ages, and the sixteenth and seventeenth centuries saw further notes added. One of these states that the book had 344 pages, rather than the present 340 pages. The book was still associated with Kells by the people of the town in the seventeenth century, but in these years it came to Dublin. People still wrote on it, once to note that a page was missing and later that it had been retrieved. Later, Queen Victoria and Prince Albert were invited to sign it, though they in fact signed a nineteenth-century flyleaf. Some of the illustrative pages have been removed through the centuries, and some of the beginning and much of the end are also missing. It was rebound several times, at least once disastrously when the pages were dampened, and several were cropped. It remains in the Library of Trinity College Dublin, available for viewing under controlled conditions, and as the centrepiece of an exhibition.

The history of the Book of Kells was then, it is thought, started on Iona, taken to Ireland to complete and to save it, and there survived further vicissitudes. Similarly, the related high crosses on Iona survived in spite of violence or neglect. Only one of them remains intact and in the place it was first erected, at the site of Columcille's monastery and scriptorium. Crosses also survive at Kells, some of them unfinished.

We have already considered the processes that went into physically making a book and writing it. We might now consider briefly the lifestyle of those who created it. An early Christian monastery was a structured and largely self-supporting community, and one that could produce this kind of manuscript was of some size. There were people living the monastic life itself and also farmers and craftspeople, and in a society

without towns it was a place where precious goods were made and stored. People lived within the sacred boundaries, under the protection of the saint, and under the authority of the abbot, who was often a member of the same family as the founding saint. Large monasteries attracted pilgrims and penitents, including the wealthy who could contribute, and the poor who could not.

Monastic life involved long hours of prayer, silence, physical labour and penance. Life inside or outside the monastery could be harsh, dependent on the yearly cycle of nature for food. The annals tell of hard winters, destructive storms, famine, plague and pestilence among the cattle that were the mainstay of the economy. People in need came to monasteries, which were themselves affected by natural catastrophes, seeking practical aid and prayer for alleviation from more hardship. Some of those whom the monastery accommodated were men blinded and mutilated by their kinsmen to prevent them achieving local rule. Some were people who had achieved power but wanted to end their lives in penitence, in the hope of forgiveness under the protection of the founding saint, a person who had power with God.

Discipline was undoubtedly strict, but not as harsh as might first appear, and the communal life was able to provide for the pilgrim, the penitent, the monk (who might be also a priest or bishop), and the child in the school. As monasteries grew larger and wealthier, big enough to produce a book like this one, craftspeople and scholars moved to them, and their needs and those of their dependants had to be accommodated. Reforms meant that there were other communities of monks, Céli Dé, who lived according to more severe rule, and some of whom spent at least part of their lives as hermits. Less is known about the women's communities, but they followed similar rules of life.

Writing and copying was part of the monastic round, a necessary work in the early centuries of Christianity in these islands, as books were needed to spread and deepen knowledge of the scriptures and other works regarded as essential. The entire psalter in Latin was learnt by heart and recited regularly. Other parts of the scriptures, especially the gospels, were heard daily. These were then copied by those who had learnt to read.

As well as copying the psalms and other scriptures, the Irish soon began to write in their own language. Prayers and poems were composed,

some of them intended for devotional use in addition to the usual prayers, others created for public hearing, and still others that were personal, and have survived as marginal scribbles. For all the severity of the monastic life, it is clear from the surviving poetry that their composers delighted in the natural world. They wrote of the summer pleasure of writing in the open air, of watching birds, of reflecting on the goodness of nature and the food the world around them provided. They also knew what it was to be cut off for weeks by storms, and to stretch out the food stocks as they ran low. An unknown writer of the eighth or ninth century took the wind as a theme for a quatrain:

> It has broken us, it has crushed us, it has drowned us, O King of the star-bright Kingdom; the wind has consumed us as twigs are consumed by crimson fire from heaven.[4]

The harsher, wilder, aspects of nature were sometimes compared to the orderliness of monastic life. The writers also enjoyed life enough to write and illuminate with a sense of fun.

Something of both the order and pleasures of the monastic life, especially where study and the copying of books was concerned, can be seen in a poem written in Irish in the ninth century about a cat with a Welsh name, and is found in a manuscript, probably written in the 840s in the north-west of continental Europe, which then found its way to Reichenau, an island monastery in Lake Constance in central Europe. In a harmony found too in some of early Irish saints' lives, the poet tells of the relationship between human and pet, between scholarship and the ordinary world, between seeking for truth and the parallels in the daily round. There is an intimate sense of mutually valued work between monk and cat, as they undertake what God has created them for. The relationship mirrors the relationship the monks seek with God. The poem is full of further meanings that are only now being understood again as knowledge of the language and the society in which the poem was made increases.[5]

The early-twentieth-century translation by the Englishman Robin Flower has become a poem in its own right. It is a work that has been frequently reinterpreted, like the Book of Kells has been reinterpreted, giving pleasure to new audiences.

I and Pangur Bán, my cat,
'Tis a like task we are at;
Hunting mice is his delight.
Hunting words I sit all night.

Better far than praise of men
'Tis to sit with book and pen;
Pangur bears me no ill-will,
He, too, plies his simple skill.

'Tis a merry thing we see
At our tasks how glad are we,
When at home we sit and find
Entertainment to our mind.

Oftentimes a mouse will stray
In the hero Pangur's way;
Oftentimes my keen thought set
Takes a meaning in its net.

'Gainst the wall he sets his eye
Full and fierce and sharp and sly;
'Gainst the wall of knowledge I
All my little wisdom try.

When a mouse darts from its den,
O! how glad is Pangur then;
O! what gladness do I prove
When I solve the doubts I love.

So in peace our task we ply
Pangur Bán, my cat, and I;
In our arts we find our bliss,
I have mine, and he has his.

Practice every day has made
Pangur perfect in his trade;
I get wisdom day and night,
Turning darkness into light.[6]

Pangur Bán's human companion may have found a lesson in the cat's attention to detail, but perhaps not everyone had the same experience. There were the usual problems in pursuing the life of prayer. One of the poems that has come down from these centuries deals with the difficulties of concentration:

How my thoughts betray me!
How they flit and stray![7]

While the natural light would have determined the routine of the day, there are also references to particular devotional and penitential acts, such as night-time vigils, sometimes undertaken communally, especially at the great feasts of the liturgical calendar. Not only cross-vigils, standing at prayer with the arms wide to emulate Christ on the cross, but vigils in the sea seem to have been practised, in emulation of the practice of the Desert Fathers in their milder, if more disease-laden, waters. The writers of the later saints' lives were not averse to making fun of taking such spiritual exercises too far. One man became crippled by too many genuflections, while Kevin of Glendalough remained in a cross-vigil for so long that a blackbird nested in his outstretched hand.

Writing may have been undertaken throughout the year, in the quiet winter, when the daylight hours were short and the main distraction was cold, and, it seems from the poetry, also in the summer, when writing was interspersed with the demands of the pastoral and agricultural year. Calves were born in the spring and the process of preparing vellum began. Collecting the various vegetable materials for dyes would have been work of summer months; and this was also the period for trade, when dyes from further away could be acquired. It was also the time for visitors, including monastic visitors with their own books and accounts of books and buildings seen abroad, and it is through surviving letters, commentaries and saints' lives that we gain insights into their influence.

The scholars who compare the iconography of ancient books in different places have identified details that show something of the movement of books and ideas in the early Middle Ages, a time once known as the Dark Ages. There are multiple influences on the Book of Kells, from earlier Irish and insular books, and from continental sources. One of the visitors to Iona whose influence has already been considered was Arculf from Gaul, whose description of the great church built upon the site of Christ's death and tomb may have influenced some of the illuminations in the Book of Kells.

A modern audience does not usually reflect theologically on architectural plans nor expect to find a design modelled physically, culturally and spiritually on the 'place of resurrection' of the firstborn from the dead, Jesus at Jerusalem. But Arculf's design must have seemed to have particular relevance for an early Christian Irish monastery, which was also a 'place of resurrection'. Irish monasteries were, moreover, roughly circular enclosures, on the pattern of secular dwellings, and so felicitously emulated the circular building at the place of the resurrection in Jerusalem. The perfect form was an enclosure of three concentric circles, the inner one the most holy. This plan could not always be carried out, and at Iona the enclosure was rectangular.

The ditch and dyke surround and identify the sacred space, show the sanctuary it provides, and give practical protection against the wind on the gardens and the encroachment of grazing animals. The boundaries had gates at certain points, where crosses were often set up, first in wood, then stone. There seem to have been special processions around the enclosures at times, a way of blessing the boundaries and identifying the most sacred parts.

Influences from other parts of Christendom can be seen in the remains of a psalter written about the same time as the Book of Kells. This book was found in 2006 in Fadden More bog in the Irish midlands, where it was buried and covered by a white cow-hide, which may have been meant as a marker for its retrieval. Little remained of the psalter, except its initial page, written and decorated in the style of other early Irish books, and some other fragments. It was important enough for someone to hide it, perhaps at a time of attack, but was found in a leather cover, which had not been treated well by the original owners. Attempts

Connection and Composition

had been made to sketch out rough interlace patterns on it, suggesting that the book it contained was used for teaching in a monastic school. Most tellingly, the leather, painted black outside, was full of holes and came from a creature that had suffered badly from warble fly. It is thought that it was lined with papyrus and probably came from Egypt.[8]

The Book of Kells was covered in earlier times, as it was stolen for the value of the cover. There may have been also a box-like shrine that would keep it dry and protect it from the mice depicted within its illustrations.

The making of a book involved the whole community, and concerned the time spent in formal prayer, alone or together, and the daily round of work. It was a spiritual task, and within it were numerous practical activities in making and preserving it, so that it could continue to be a source of spiritual reflection and interpretation. It was a status symbol, a prized relic, and a wonder of the known world, but it was in essence a copy of the gospels, the core of their understanding of life, the story of Jesus, who became incarnate, lived, died and rose again. It also honoured their founder Columcille and others of the monastic family who had died before them.

After the time-consuming task of preparing the vellum, refining and cutting it when dry, and then ruling it, the writing would be done largely with quills, prepared from the tail feathers of geese or similar large birds, some of them domesticated. Other tools included fine brushes made from the fur of small animals, probably the pine marten for delicate work, and the wooden implements and other items made in the monastery.

Tools needed to design the illuminations included set squares and compasses, and some have left prick marks in the vellum. All the designs would have required much planning and practice, and then came the laborious process of outlining them. This was followed by adding a colour, which then had to dry before another colour was applied. Borders had to be finely drawn and straight, and there were often multiple lines to make. Stippling outlines with red and colouring in the minor capitals followed, again requiring a steady hand. Some of the smallest spirals are so regular and fit so well that they may have been stamped on, using the skills and materials from the silverwork in which this society excelled.

There is variety and ingenuity in both the colours and the design. The canon tables are presented in classical-style arches, showing what the artists could take from the centre of Christendom. The community's

orthodoxy can be seen in the repeated presentation of the intertwined images of the evangelists and their symbols to emphasise the unity of the gospels. The illustrations that carry theological weight and were designed for liturgical use would have been based in part on ones they had seen in other gospels, available in their own scriptorium, or seen and reported by travellers. The artists adapted what they saw and heard to make the work unique; a product of their own culture. Their practice may have been severe, but they made the expression of it joyful. It was, for the artists and writers, part of their journey to God.

Most of the ink is darkish brown and comes from oak galls, though holly is also referred to as a source. Some may have been local, others imported; the European gall wasp that lays its eggs on the tree which forms the gall around it lives further south. Galls were dried, crushed and heated at the scriptorium. Sometimes very black ink, based on soot, was also used.

Egg white was used to create and fix colours. Domestic fowl were kept, and in the Book of Kells a cock and hens meet on the line above the Parable of the Sower. Perhaps it recalls an actual event in the monastery, when the fowl got onto newly sown land. The collection of eggs on a larger scale would have involved sea birds, often those nesting on cliffs, a skilled task. Fish and cheese glues, fruit gums, egg yolk and possibly honey were all used to form colours and make them adhere to the page, while fruit gums also provided a glaze.

The palette of the Book of Kells is wide and includes both expensive imported substances and locally available but perhaps labour-intensive ones. The colours involved considerable preparation, even those made of local materials. For all the pleasure they give to the onlooker, the use of some of them must have been among the daily penances of the monastic round, for those exposed to their smells and their hazards. Other colours used products of the seashore and lichen, which needed gathering.

White gypsum was used for the faces of humans and angels, in a departure from European practice of the time where colour derived from earth dyes were used, with light from within portrayed by painting over a thin sheet of gold.[9] The blue-greens are copper-based, an unstable substance that can eat through vellum. Mixed with white lead it forms opaque colours, but was also used as a backing for blues. Due to reaction

with water some greens in the Book of Kells have run and faded since the pages were dampened in an attempt to smooth them in the nineteenth century. The bright reds come from lead and were formed by dangerous and poisonous processes. In many places the red has flaked off, giving only an indication of the original vivid designs. The darker crimsons and softer colours are created from the crushed carcasses of Mediterranean beetles, while the pinks and purples come from plants, and there are local vegetable dyes which produce a range of colours. No gold is used at all, but the imported yellow orpiment, a foul-smelling but brilliant substance, retains some of its original visual effect.

The blues are perhaps the most notable, for blue was used in other earlier gospel books like Lindisfarne, but was not a tradition in eastern iconography, though it was later to become very popular in Europe, especially for the painting of the Virgin Mary. The pages in the Book of Kells contain everything from the lightest opaque turquoises, used for example on the Easter page, to the deep blues associated with the Passion. The blues are plant-based and come from woad, which could be grown as far north as Ireland, for it is mentioned in the early Irish laws, and was also used to dye clothing which gave status to the wearer. The production by which the yellow flowers of woad were turned into an alkaline sludge, which then oxidised and formed brilliant blues, was slow and smelly, but chemically precise; and we have retained the French name, 'pastel', with a wider meaning. It was believed until recently that the most brilliant blues came from lapis lazuli, a precious stone imported from what is now Afghanistan and that was more valuable than gold, but recent testing indicates that the colour comes from the local dye, woad, and produced by these skilful means. Mixed with yellow it produced another green.

Perhaps most beautiful of all are the layers of colour wash superimposed, in particular upon the clothing of figures. This gives them texture that lifts them off the page and catches the light, to give an iridescent effect, emulating movement. Some of the angels seem to have just alighted on the page, an effect still discernible after all the damage the Book of Kells has incurred. The border panels and the layers of colour give the page a texture, depth, luminosity and richness that even the ravages of age and the mishandling of centuries have not been able to obliterate.

The Book of Kells has survived, where other gospel books are lost, or are wonderful in their own right but do not stretch our imagination as this one does, as it raises the art to a new height and continues to inspire viewers. Françoise Henry unlocked many of the technical aspects, while George Otto Simms showed how the pictures could be used meditatively: his short book continues to be in demand and has been translated into several languages. Scholarship since the 1990s has sought to uncover the influences on the book and the theological and liturgical intentions of the artists. This work is detailed and exacting, requiring highly specialist knowledge, and it forms the backbone to our understanding. It allows the onlooker, within the confines of our own culture, to use the illuminations as originally intended, as means to explore the nature of God as revealed in the scriptures.

In doing so, we are learning more about the original intentions, and how the people who produced this work lived, where they travelled, how they engaged economically, what influenced them, and what they valued. We can also understand more as we read the poetry, formal or personal, in which they expressed something of their lives, and which continue to delight. Some of this poetry was translated in the years when Celtic Studies was a relatively new university discipline, and the authors were influenced by the contemporary literary movement, known as the Celtic Twilight or Celtic Revival, and by a need to prove that the Celtic world produced literature on par with that of the dominant cultures of Europe. They followed the fashion of the time in trying to render the translations as poems in their own right, and sometimes clarity may have been sacrificed for metre and rhyme. But many were produced by competent scholars in love with their subject like the German Kuno Meyer and Eleanor Hull.

The mid-twentieth century was a time when Celtic Studies became more established as a discipline, and work was progressing on a better understanding of the Irish language in its different phases. A small number of scholars edited the original poems together with translations, and published collections in books intended primarily for use by students but also to bolster the quantity of literature available in Irish. Some scholars, like James Carney, presented translations in poetic form, while others like David Greene worked with the poet Frank O'Connor to produce

works that sought to respect but not be constrained by the form of the original. Helen Waddell produced poetic translations from the Latin, while Kenneth Jackson gave his versions in prose. Modern translations benefit from detailed scholarship. The tendency today is to give literal translations, leaving separate notes on metres and on obscure words. This provides precision, but concentration on the linguistic elements rather than the content or form of the poems limits understanding of the extent to which they were memorised and recited.

Modern versions of 'Celtic spirituality' can be very heavily derived from a small group of texts, and there is a temptation to create new interpretations to suit contemporary tastes and concerns. But our understanding of the 'Celtic' is hugely enriched by returning to the sources, written and visual; by taking the older translations as creations that have contributed to our understanding; and by using the new and more literal translations to explore something of what our ancestors held dear. In doing this we can value them in their own terms, as far as we can understand them, rather than in terms of what we want to find.

Published anthologies of the poetry are relatively easy to find, and the opportunities to view the Book of Kells in some form are increasing. While the entire Book of Kells can be viewed online, no book or screen can as yet give a sense of the texture, of the way in which some of the illuminations appear to be raised off the page, but they allow the onlooker time to explore the meanings, to see much of the detail, and gain a sense of the overall work. It undoubtedly continues to inspire, as the numbers visiting can testify. There are many derivatives, such as books and films for children and adults that reproduce some of the designs. On another level, reproductions of a single page can be the focus for contemplation.

The Book of Kells is a powerfully spiritual work of art that offers an interpretation of the gospels. It presents a theology of the Christian message that includes some fun and a great deal of joy. There is the hint of resurrection and new life even in the darkest pages. The fact that there is a sequence, and inter-relationship between the illuminations, and between each of them and the text, can broaden the viewers' understanding of the scriptures, as they were seen then and as they personally resonate today.

Art can bring us back to the beginning, to see the same place with new eyes. The Book of Kells remains a delight, and provides food for reflection,

even when its purposes are obscure to a modern viewer. The illuminations cast light upon the text of scripture; enlighten us, for a personal as well as a communal journey. The original artists twelve hundred years ago could never have imagined where their great relic would journey and how it would be shown to new audiences. Battered and incomplete, its history offers a testimony to incompetence, unscrupulousness, thoughtlessness, possessiveness, reverence, stewardship, human endeavour and respect for future onlookers. Its story and its content allow it, under all the accretions, to fulfil its main purpose; to point to the Word of God and to unlock it in new ways. If we find ways to use our own ingenuity and prevent further damage to life on earth, it may well continue to delight and inspire for another twelve centuries.

NOTES

1. Ninth century, quatrain, preserved in Reichenau manuscript.

2. See the books by Brian Lacey, the work of the Iona Research Group, the Iona's Namescape Projects, Rosemary Power, 'Dating Iona's Nunnery', *Scottish Historical Review*, 2021, pp. 277–84.

3. Tr. under 1007, *The Annals of Ulster*, William M. Hennessy (ed.), 4 vols, Dublin, 1887–1901, https://celt.ucc.ie/published/T100001A.html

4. Jackson, *Celtic Miscellany*, p. 127.

5. There is an explanation of the manuscript, a list of translations and discussion about the hidden meanings in G. Toner, '"*Messe ocus Pangur Bán*": Structure and cosmology', *Cambrian Medieval Celtic Studies*, 57, 2009, pp. 1–22.

6. Pangur Bán, Robin Flower (tr.), *Poems and Translations*, London, 1931, p. 129–30; also printed in Hull, *The Poem-Book of the Gael*, pp. 132–3. Other translations have been made since, see Toner, *'Pangur Bán'*, p. 1, n. 1.

7. Tenth century, Irish. O'Connor (tr.), *A Book of Ireland*, pp. 366–8.

8. Thanks to Dr Anthony Read, Head of Conservation, National Museum of Ireland for this information.

9. Many of the scholars writing on the Book of Kells give specialist information on the pigments. For an overview, see Anthony Cains, 'The Pigment and Organic Colours' in Fox (ed.), *The Book of Kells*, pp. 211–31.

Further Reading and Works Cited

The following consists of texts cited in this book, works drawn on for their illustrations and works of scholarship that have been used here and may be a starting point for fuller exploration of the large specialist work now available. Particularly important for giving an overview are the 1992 conference proceedings, edited by Felicity O'Mahony (1994), the books by Carol Farr, Heather Pulliam and Bernard Meehan (2012), and the articles by Jennifer O'Reilly.

Gospel Books, Illustrations and Commentaries

The Book of Kells, MS 58: Trinity College Library Dublin, Commentary, P. Fox (ed.), 2 vols, Lucerne: Fine Art Facsimile, 1990.

The Book of Kells, Digital Collections, The Library of Trinity College Dublin, https://digitalcollections.tcd.ie/concern/works/hm50tr726?locale=en.

Brown, P., *The Book of Kells: Forty-Eight Pages and Details in Colour from the Manuscript in Trinity College, Dublin*, London: Thames and Hudson, 1980.

Backhouse, J., *The Lindisfarne Gospels*, Oxford: Phaidon, 1981.

Farr, C., *The Book of Kells: Its Function and Audience*, London: The British Library and University of Toronto Press, 1997.

Farr, C., 'Textual Structure, Decoration and Interpretative Images in the Book of Kells' in F. O'Mahony (ed.), *The Book of Kells: Proceedings of a Conference at Trinity College Dublin*, Aldershot: Scolar Press for Trinity College Library, 1994, pp. 437–49.

Farr, C., '*Vox Ecclesiæ*: Performance and Insular Manuscript Art' in C. Hourihane (ed.), *Insular and Anglo-Saxon: Art and Thought in the Early Medieval Period*, Princeton: Pennsylvania State University Press, 2011, pp. 219–28.

Henry, F., *The Book of Kells: Reproduced from the Manuscript in Trinity College Dublin with a Study of the Manuscript*, London: Thames and Hudson, 1974.

Hourihane, C. (ed.), *Insular and Anglo-Saxon: Art and Thought in the Early Medieval Period*, Princeton: Pennsylvania State University Press, 2011.

MacGabhann, D., *The Marking of the Book of Kells: Two Masters and Two Campaigns*, unpublished PhD thesis, University of London, 2016, https://sas-space.sas.ac.uk/6920/

MacGabhann, D., 'The et-ligature in the Book of Kells: Revealing the "Calligraphic Imagination" of its Great Scribe', in C. Newman, M. Mannion and F. Gavin (ed.), *Islands in a Global Context: Proceedings of the Seventh International Conference on Insular Art*, Dublin: Four Courts Press, 2017, pp. 138–48.

MacGabhann. D., 'Turning the Tables: An Alternative Approach to Understanding the Canon Tables in the Book of Kells', in C. Thickpenny, K. Forsyth, J. Geddes and K. Mathis (eds), *Peopling Insular Art: Practice, Performance, Perception: Proceedings of the Eighth International Conference on Insular Art, Glasgow 2017*, Oxford and Havertown (Philadelphia): Oxbow Books, 2020, pp. 13–22.

Meehan, B., *The Book of Kells: An Illustrated Introduction to the Manuscript in Trinity College Dublin*, London: Thames and Hudson, 1994.

Meehan, B., *The Book of Durrow: A Medieval Masterpiece at Trinity College Dublin, Dublin*: Town House Trinity House, 1996.

Meehan, B., *The Book of Kells*, London: Thames and Hudson, 2012.

Netzer, N., 'The origin of the Beast Canon Tables reconsidered' in F. O'Mahony (ed.), *The Book of Kells: Proceedings of a Conference at Trinity College Dublin*, Aldershot: Scolar Press for Trinity College Library, Dublin, 1994, pp. 322–32.

Netzer, N., 'New Finds versus the Beginning of the Narrative in Insular Gospel Books' in C. Hourihane (ed.), *Insular and Anglo-Saxon: Art and Thought in the Early Medieval Period*, Princeton: Pennsylvania State University Press, 2011, pp. 3–13.

O'Mahony, F., *The Book of Kells: Proceedings of a Conference at Trinity College Dublin*, Aldershot: Scolar Press for Trinity College Library, 1994.

O'Reilly, J., 'Exegesis and the Book of Kells: the Lucan Genealogy' in F. O'Mahony (ed.), *The Book of Kells: Proceedings of a Conference at Trinity College Dublin*, Aldershot: Scolar Press for Trinity College Library, 1994.

O'Reilly, J., 'St John the Evangelist: Between Two Worlds' in C. Hourihane (ed.), Insu*lar and Anglo-Saxon: Art and Thought in the Early Medieval Period*, Princeton: Pennsylvania State University Press, 2011, pp. 189–218.

Porter, C., 'Plants to Page: workshop on the Palette of the Book of Kells', unpublished lecture given at the Historic Environment Scotland and Iona Community Saint Columba's Week Conference, Iona, June 2014.

Pulliam, H., *Word and Image in the Book of Kells*, Dublin: Four Courts Press, 2006.

Pulliam, H., 'Looking to Byzantium: Light, Color and Cloth in Insular Art' in C. Hourihane, *Insular and Anglo-Saxon: Art and Thought in the Early Medieval Period*, Princeton: Pennsylvania State University Press, 2011, pp. 59–78.

Simms, G.O., *Exploring the Book of Kells*, Dublin: O'Brien Press, 1988.

Werner, M., '*Crucixi, Sepulti, Suscitati*: Remarks on the Decoration of the Book of Kells' in F. O'Mahony (ed.), *The Book of Kells: Proceedings of a Conference at Trinity College Dublin*, Aldershot: Scolar Press for Trinity College Library, 1994, pp. 450–88.

Poetry

Blathmac, *The Poems of Blathmac, Son of Cú Brettan*, J. Carney (ed.), Dublin:
 Educational Co. of Ireland, 1964.

Carey, J., *King of Mysteries: Early Irish Religious Writings*, Dublin: Four Courts
 Press, 2000.

Carney, J. (tr.), *Medieval Irish Lyrics*, Dublin, 1967, reprinted with *The Irish Bardic
 Poet*, Dublin: Dolmen Press, 1985.

Clancy, T. and G. Márkus, *Iona: The Earliest Poetry of a Celtic Monastery*,
 Edinburgh: Edinburgh University Press, 1995.

Flower, R. (tr.), *Poems and Translations*, London, 1931 [London]Constable & Co,
 [1931], rep. Dublin: Lilliput Press, 1993.

Greene, D. and F. O'Connor, *A Golden Treasury of Irish Poetry*, AD 600–1200,
 London: Macmillan, 1967, reprinted Dingle: Brandon, 1990.

Hull, E., *The Poem-Book of the Gael*, London: Chatto and Windus, 1913.

Jackson, K., *Studies in Early Celtic Nature Poetry*, Cambridge: Cambridge
 University Press 1935.

Jackson, K. (tr.), *A Celtic Miscellany*, 1951, revised Harmondsworth: Penguin, 1971.

MacMurchaidh, C. (ed.), *Lón Anama: Poems for Prayer from the Irish Tradition*,
 Dublin: Cois Life, 2005.

Márkus, G., *Admonán's 'Law of the Innocents': Cáin Adomnáin*, Kilmartin [Argyll]:
 Kilmartin House Trust, 2008.

Meyer, K., *Selections from Ancient Irish Poetry*, London: Constable and Co., 1911.

Murphy, G., *Early Irish Lyrics: Eighth to Twelfth Century*, Oxford: Clarendon Press,
 1956; second edn, Dublin: Four Courts Press, 1998.

Murray, P., *The Deer's Cry: A Treasury of Irish Religious Verse*, Dublin: Four Courts
 Press, 1986.

O'Connor, F. (ed.), *A Book of Ireland*, Glasgow: Collins, 1959.

Ó Laoghaire, D., *Ár bPaidreacha Dúchais*, Dublin: FÁS, 1982.

Waddell, H. (tr.), *Medieval Latin Lyrics* (1929), Harmondsworth: Penguin, 1929, 1952.

Other Works

The Annals of Ulster to AD 1131, S. Mac Airt and G. Mac Niocaill (ed. and tr.),
 Dublin: Dublin Institute for Advanced Studies, 1983.

Adomnán of Iona, *Adomnán's De locis Sanctis*, D. Meehan (ed. and tr.), Dublin:
 Dublin Institute for Advanced Studies, 1983.

Adomnán of Iona, *Life of St Columba*, R. Sharpe (tr.), Harmondsworth: Penguin, 1991.

Bede, *Ecclesiastical History of the English People*, L. Sherley-Price (tr.), revised by
R.E. Latham, with introduction and notes by D.H. Farmer, Harmondsworth:
Penguin, 2001.

Carver, M., *Portmahomack: Monastery of the Picts*, Edinburgh: Edinburgh
University Press, 2008.

CELT, Corpus of Electronic Texts, A project of University College, Cork, https://
celt.ucc.ie.

Dictionary of the Irish Language based mainly on Old and Middle Irish Materials,
Dublin: Royal Irish Academy, 1913–76, www.dil.ie.

Giraldus Cambrensis, Gerald of Wales, *The History and Topography of Ireland*, J.
O'Meara (tr.), revised edition, Harmondsworth: Penguin, 1982.

Harbison, P., *The High Crosses of Ireland: An Iconographical and Photographic
Survey, vol. 1: Text; vol. 2: Photographic Survey; vol. 3: Illustrations of Comparative
Iconography*, Mainz: Römisch-Germanisches Zentralmuseum, 1992.

Harbison, P., *The Crucifixion in Irish Art*, Dublin: Columba Press, 2000.

Herbert, M., *Iona, Kells and Derry: The History and Hagiography of the Monastic
Familia of Columba*, Dublin: Four Courts Press, 1988, 1996.

Herren, M.W. and S.A. Brown, *Christ in Celtic Christianity: Britain and Ireland from
the Fifth to the Tenth Century*, Woodbridge: Boydell Press, 2002.

Hughes, K. and A. Hamlin, *The Modern Traveller to the Early Irish Church*,
London: SPCK, 1977.

Iona Research Group, https://ionaresearchgroup.arts.gla.ac.uk

Iona's Namescape Projects, https://iona-placenames.glasgow.ac.uk

Columba and Iona: An Interdisciplinary Conference, 9–10 December 2021. Iona's
Namescape Projects, https://iona-placenames.glasgow.ac.uk. (Note: Papers
forthcoming.)

Irvine, C., *The Cross and Creation in Christian Liturgy and Art*, London: SPCK, 2013.

Lacey, B., *Columcille and the Columban Tradition*, Dublin: Four Courts Press, 1997.

Lacey, B., *Saint Columba: His Life and Legacy*, Dublin: Columba Press, 2013.

Lacey, B., *Adomnán, Adhamhnán, Eunan: Life and Afterlife of a Donegal Saint*,
Dublin: Four Courts Press, 2021.

Meek, D., *The Quest for Celtic Christianity*, Edinburgh: Handsel Press, 2000.

Meyer, K. (ed. and tr.), *Hibernica Minora: A Fragment of an Old-Irish Treatise
on the Psalter*, Oxford: Clarendon Press, 1894, www.ucd.ie:80/tlh/trans/
km.hm.001.t.text.html.

Ó Carragáin, T., *Churches in Early Medieval Ireland: Architecture, Ritual and Memory*, New Haven and London: Yale University Press, 2010.

O'Loughlin, T., *Adomnán and the Holy Places: The Perceptions of an Insular Monk on the Locations of the Biblical Drama*, London and New York: T and T Clark, 2007.

O'Neill, T., *The Irish Hand: Scribes and Their Manuscripts from the Earliest Times to the Seventeenth Century with an Exemplar of Irish Scripts*, Cork: Cork University Press, 1984, 2014.

Petzold, A., '"Of the Significance of Colours": The Iconography of Colour in Romanesque and Early Gothic Book Illuminations' in C. Hourihane (ed.), *Image and Belief: Studies in Celebration of the Eightieth Anniversary of the Index of Christian Art*, Princeton: Princeton University Press, 1999, pp. 125–34.

Power, R., *The Celtic Quest*, Dublin: Columba Press, 2010.

Power, R., *The Story of Iona: Columban and Medieval Sites and Spirituality*, London: Canterbury Press, 2013.

Power, R., 'Dating Iona's Nunnery', *Scottish Historical Review*, 2021, pp. 277–84.

The Secret of Kells, animated Irish-French-Belgian film, written by F. Ziolkowski and T. Moore, directed by T. Moore and N. Twomey, Kilkenny: Cartoon Saloon, 2009.

Toner, G., '"*Messe ocus Pangur Bán*": Structure and cosmology', *Cambrian Medieval Celtic Studies*, 57, 2009, pp. 1–22.